DRAWN IN

DRAWN IN

A PEEK INTO THE INSPIRING SKETCHBOOKS
OF 44 FINE ARTISTS, ILLUSTRATORS,
GRAPHIC DESIGNERS, AND CARTOONISTS

Presented by *Book By Its Cover* author JULIA ROTHMAN

Foreword by Vanessa Davis

First published in the United States of America in 2011 by
Quarry Books, a member of Quayside Publishing Group

100 Cummings Center
Suite 406-L
Beverly, Massachusetts 01915-6101
Telephone: 978.282.9590
Fax: 978.283.2742
www.quarrybooks.com

Visit www.craftside.typepad.com for a behind-the-scenes
peek at our crafty world!

10 9 8 7 6 5 4 3 2 1

ISBN-13: 978-1-59253-694-8
ISBN-10: 1-59253-694-8
Digital edition published in 2011
e-ISBN-13: 978-1-61058-023-6

Library of Congress Cataloging-in-Publication Data available

DESIGN: ALSO
PHOTOGRAPHY: ALSO & Kipling Swehla

CONTENTS

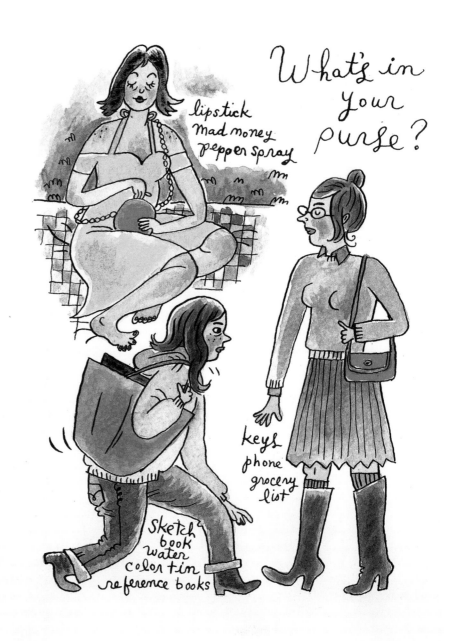

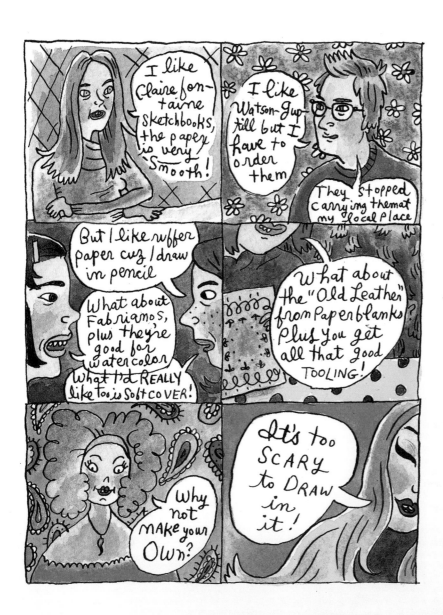

INTRODUCTION

While recently riding on a very crowded subway from Brooklyn to Manhattan, I noticed an artist who was sketching me as he leaned against the back wall of the subway car. Holding steady his small sketchbook, he scrawled rapidly in pencil. We made eye contact. I may have blushed. He quickly looked away, pretending he hadn't been drawing me. A few minutes later, I noticed he was sketching a woman sitting across from me. As the door opened at my subway stop, I made my way through the passengers and squeezed behind the artist hoping to peek into his book. I was curious to see how he had portrayed us. Unfortunately, that proved impossible, and so I never had a glimpse.

It is regrettable that the personal art work that sketchbooks contain are rarely made public. Within sketchbook pages, one can trace the development of an artist's process, style, and personality. Sketches emit a freshness and vitality because they are the first thoughts and are often not reworked. Raw ideas and small sketches are the seeds for bigger projects. Sketchbooks ultimately become the records of artists' lives. They are documented visual diaries.

Three years ago, I started a blog called *Book By Its Cover.* I sought a way to share the love I have for all the art books I have collected plus all the new books just coming out. Five days a week, I write a short review of a book, show a series of images that I have photographed from inside that book, and supply links to where you can buy it. When my blog gained in popularity, I realized I wasn't alone in my obsession for beautiful books.

The Internet has made it easier to find out about artists world-wide. Shortly after creating the blog, I discovered a pool of images on Flickr from the inside of small Moleskine sketchbooks. Russian, Canadian, and Spanish artists revealed how they painted, collaged, and sketched into these tiny 3.5" x 5.5" (8.9 x 14 cm) blank notebooks, transforming them into art. They were so impressive! I received permission to show these on the blog as a special feature. Readers of my blog commented on the uniqueness of these sketchbooks. Many readers were so inspired, they hurried out to purchase a Moleskine and started their own sketchbooks. Their reactions combined with my intense interest led me to think about posting more artist sketchbooks.

The designer, Isaac Tobin, immediately came to mind even though it had been eight years since we had graduated from Rhode Island School of Design together. He collaged found materials, drew, and painted on his pages. He folded paper so that it popped out when you turned the page. His sketchbooks were works of art that were framable.

After the posting of Isaac's sketchbook and all the positive feedback it received, I decided to start a series sharing my other favorite artists' sketchbooks. I sent out an email to twenty artists inviting them to contribute. Many said they were honored but never kept sketchbooks; others never responded. But a handful did answer positively and sent photos and commentary. Every Friday I began to post a new artist's sketchbook, and this became the most popular section of my site.

When a new review is posted on my blog each day, older posts retreat into the archives. I was concerned that all this beautiful private work could be lost or hidden once again. I longed to create my own sketchbook anthology featuring this unseen artwork. I also wanted to uncover more sketchbooks, and a published book was a nice entryway into involving new artists.

Some of the sketchbooks featured in this book may seem like finished art. In Ben Finer's sketchbook, each page is filled to the edges with intricate patterning and drawings. The pages feel like completed pieces of art. Other artists fill space with loose pencil sketches, thumbnail drawings, and bits of writing. There is a mix of styles and media, a range of fine art artists, comic artists, designers, and illustrators. Some have used paint and their pages have begun to curl up. Other sketchbooks are so filled that the bindings are expanding and breaking. Some pages feel heavy and thick from all the collaged-in papers. Often, while turning a page, a clipping, an old ticket, or a leaf, slides out from between the sheets. Those resemble scrapbooks, while many other artist's sketchbooks are neat and clean. Renata Liwska's is tiny and perfectly kept. Each pencil drawing is so delicately drawn and the facing page is blank to prevent smudging.

I had all of the artist sketchbooks sent directly to me to be photographed. I could never have anticipated the feeling of holding these books in my hands. I have followed Anders Nilsen's comics for years. And now here in front of me was a pile of his personal work—a small stack of worn Moleskines. I think I held my breath turning the first few pages, feeling completely overwhelmed being able to see his unpublished comics, his sketches of people in cafés, and his abstract pen drawings.

I feel privileged that so many artists I have admired over the years have shared their private sketchbooks for this book. I so hope you can appreciate these pages as much as I do.

ANA BENAROYA

New Brunswick, New Jersey
www.anabenaroya.com

Ana Benaroya is an illustrator
and a designer working out
of New Jersey. She loves hot
sauce, muscular men, and bright
colors. Previously, she worked
as a designer for *Nickelodeon
Magazine* and has done
illustrations for clients such
as the *New York Times, Poetry
Magazine,* designer Marc Ecko,
the band, Wilco, and *ABC
World News Tonight.* In her free
time, she ponders the meaning
of life.

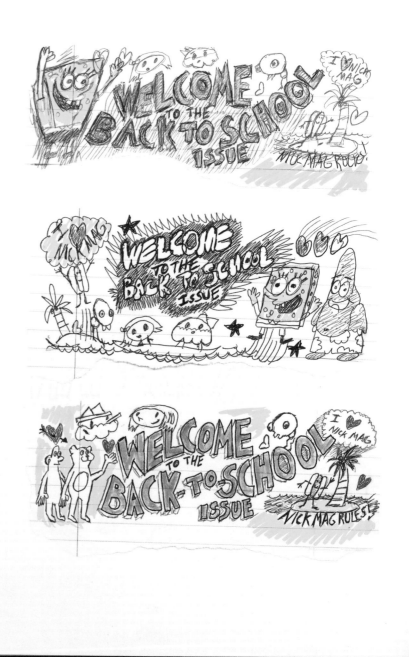

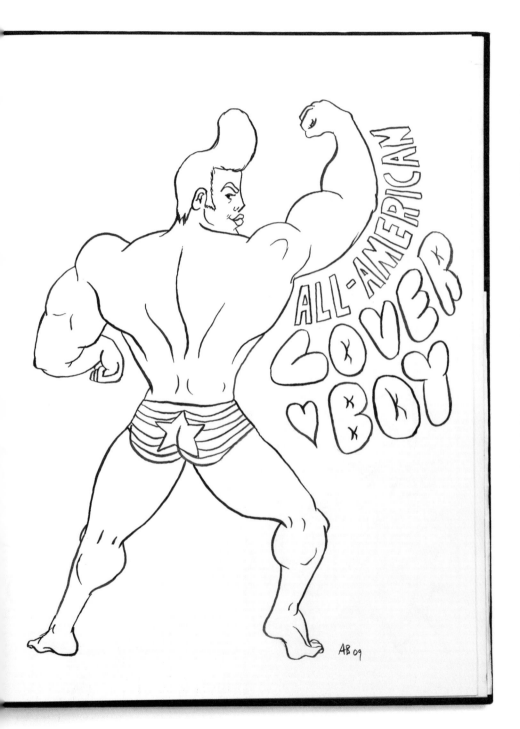

WHAT ARE THE MAIN FUNCTIONS OF YOUR SKETCHBOOK?
Pretty much I work exclusively in my sketchbooks, both for personal and for professional work. I feel less pressure by working this way, and it has the nice bonus that everything is kept together and I don't lose anything.

I NOTICED YOU DRAW A LOT OF MUSCLE MEN. WHY DO YOU LIKE DRAWING THAT KIND OF IMAGERY?
I think I just love the human body, and I love drawing it in its most extreme form. When I was a little girl I loved superheroes and collected action figures, so it probably all started there. It is also possible that I have the mind of a gay man and therefore love muscular, pretty men and rainbow colors.

THE TWO SKETCHBOOKS YOU ARE SHARING ARE BOTH EXACTLY THE SAME, LARGE SIZE. WHY THIS SIZE? HAVE YOU TRIED SMALLER SKETCHBOOKS?

I like being able to fit multiple projects/ideas on one page. And I always found myself starting a drawing and falling off the page in my smaller sketchbooks, so I thought, why not just get a bigger one? I view these large sketchbooks as my "home" sketchbooks, and I carry a smaller Moleskine around with me in my purse.

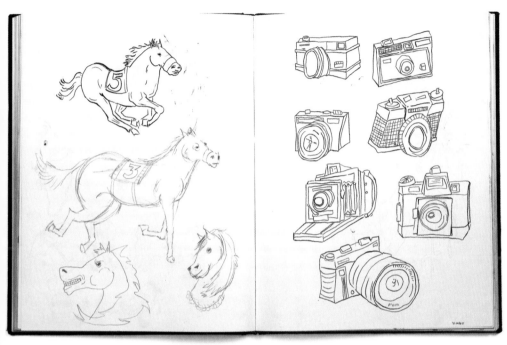

HOW DOES IT FEEL TO LOOK AT YOUR OLD SKETCHBOOKS?

I love looking back at my old sketchbooks, especially my childhood sketchbooks. I remember thinking at the time how great some of my drawings were. I look at them now and laugh. I also find it funny to see that I keep coming back to the same themes over and over—since childhood. I guess nothing changes.

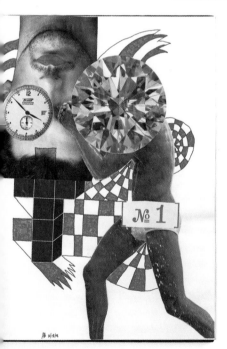

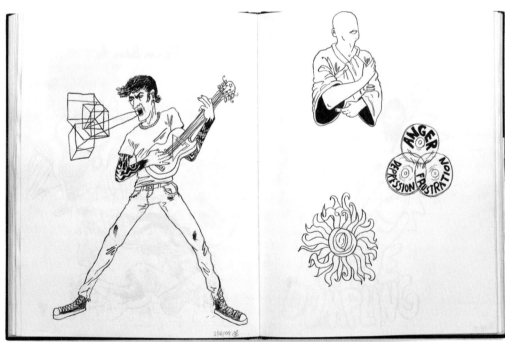

SOPHIE BLACKALL

Brooklyn, New York
www.sophieblackall.com

Sophie Blackall is a Brooklyn–based, Australian illustrator of more than eighteen children's books, including *Ruby's Wish* (for which she won the Ezra Jack Keats Award) and *Meet Wild Boars* (which won the Society of Illustrators Founder's Award). She also illustrates magazine articles, animated TV ads, CD

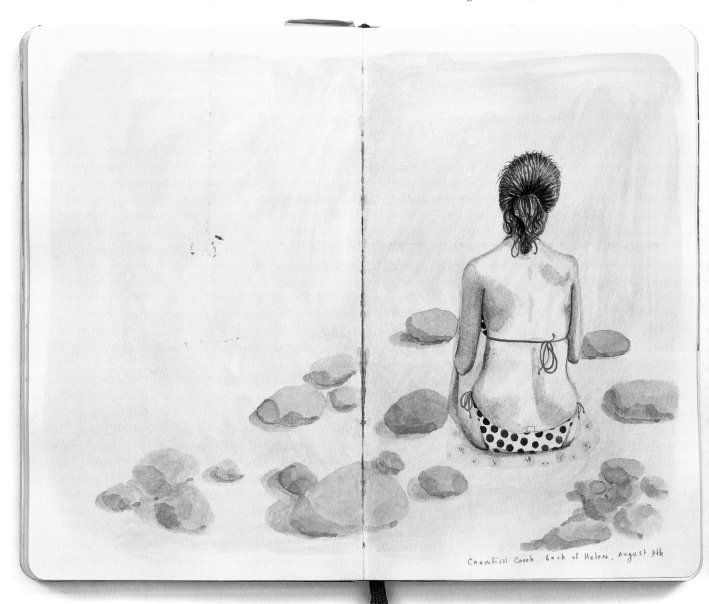

Crawfish Creek, Book of Helen, August 9th

covers, and the occasional friend's tattoo. Her latest project, *Missed Connections*, which began as a blog in early 2009, is an ongoing series of paintings based on real, anonymous messages posted online by lovelorn strangers. Reproachable eavesdropper and unflinching thief of other people's stories, she is always on the lookout for glimpses of unexpected intimacy and stores them away as pictures in her overcrowded head. A book of her *Missed Connections* paintings, called *You Probably Won't Read This*, will be published by Workman in 2011.

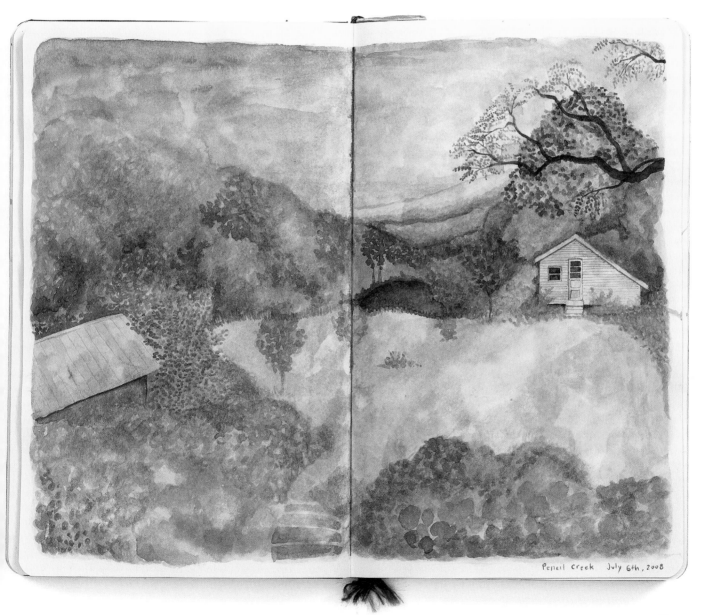

Pencil Creek July 6th, 2008

WHAT ARE THE MAIN FUNCTIONS OF YOUR SKETCHBOOKS?

My sketchbooks are travel journals. I almost always slip one into my bag when I leave the house, whether it's for a quick trip into Manhattan on the subway or a twenty-four-hour flight to Australia. They serve as a souvenir of my travels; I draw in them every day when I'm away from home.

WHAT MEDIUMS DO YOU WORK WITH IN YOUR SKETCHBOOK? HOW DOES THAT DIFFER FROM YOUR PROFESSIONAL WORK?

I paint in Chinese ink or watercolor or sketch in pencil, depending on where I am and if I'm trying to balance a paint water vessel on my knee on a windy cliff. In my professional work, I paint religiously on hot press watercolor paper; the paper in my sketchbooks is kind of waxy, but I like the difference. It feels liberating.

ARE THERE ANY CHILDHOOD MEMORIES THAT STICK OUT IN YOUR MIND THAT MAY HAVE IMPACTED YOUR ARTISTIC LIFE IN SOME WAY?

When I was twelve, I papered my bedroom wall with *New Yorker* covers, carefully excised from my father's archived collection. I used to lie in bed and stare at the illustrations thinking, "One day, I'm going to do that."

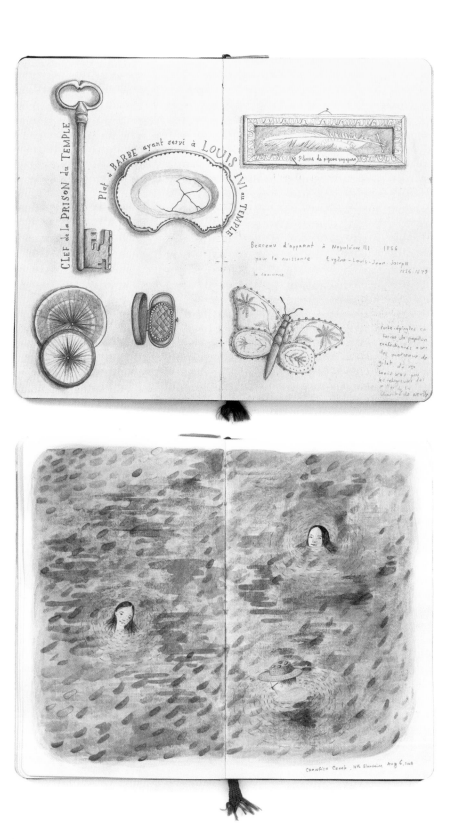

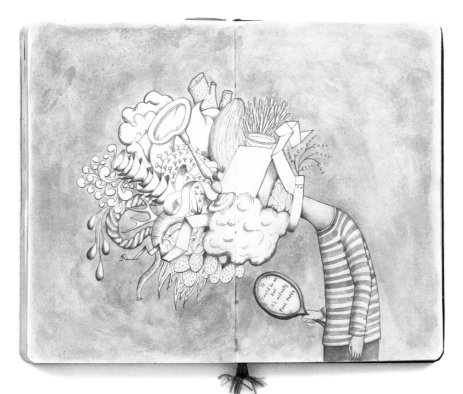

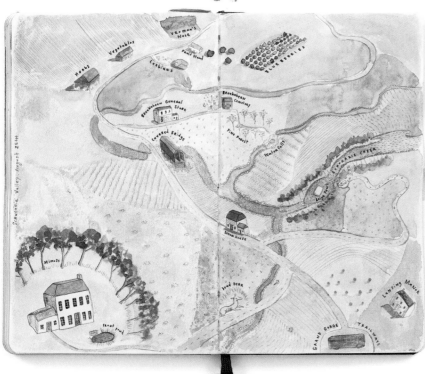

HAVE YOU NOTICED RECURRING THEMES IN YOUR SKETCHBOOKS?

My sketchbooks are filled with landscapes and portraits, neither of which I usually paint. The pictures are all drawn from observation, whereas in my professional work, most of my imagery comes from inside my head. My professional work is whimsical and funny and slightly dark. My sketchbooks rarely have a conceptual image or an imaginative one. It's a place for other side of the brain drawing.

YOU COLLECT LOTS OF THINGS. CAN YOU TELL ME WHAT THINGS YOU COLLECT AND IF THEY'VE IMPACTED YOUR ARTWORK IN ANY WAY?

I collect single Victorian children's shoes, vintage suitcases, teenage girls' scrapbooks from the '20s and '30s, early doll parts, antique hand mirrors, printed flour sacks, and animals that have been turned into other things in another century, like a deer hoof into a pincushion or a whale bone into a letter opener, among other things. I created an installation at the Brooklyn Public Library that incorporated a lot of things from my collection. These old things and the fragments of stories they hold definitely inform my work. They are under the surface of everything.

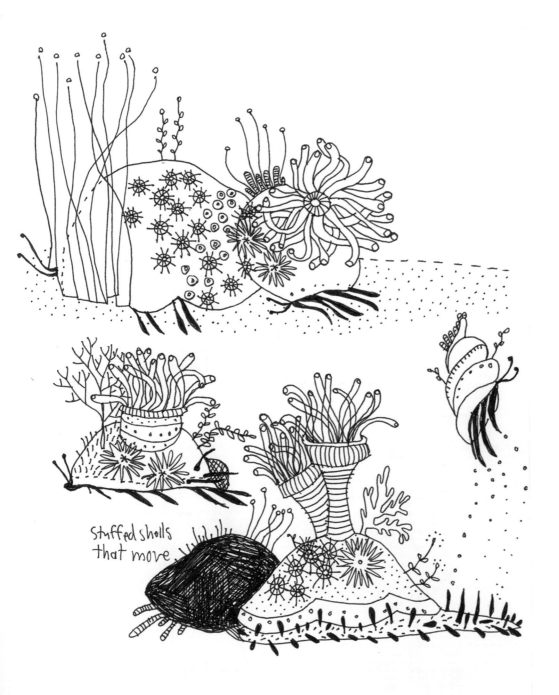

stuffed shells
that move

JILL BLISS

Portland, Oregon
www.jillbliss.com

Combining studio art, graphic
design, and craft culture, Jill
Bliss uses everyday items such
as pens, fabric scraps, paper
cuttings, and basic thread to
make objects that are unique—
stationery, household items,
office supplies, and artwork. Her
deceptively simple, nature-
inspired style stems from her
growing up in a do-it-yourself
household surrounded by nature
in Northern California and
then going to art school. Since
2001, Jill has been selling her
work directly to fans online
and via indie boutiques around
the world.

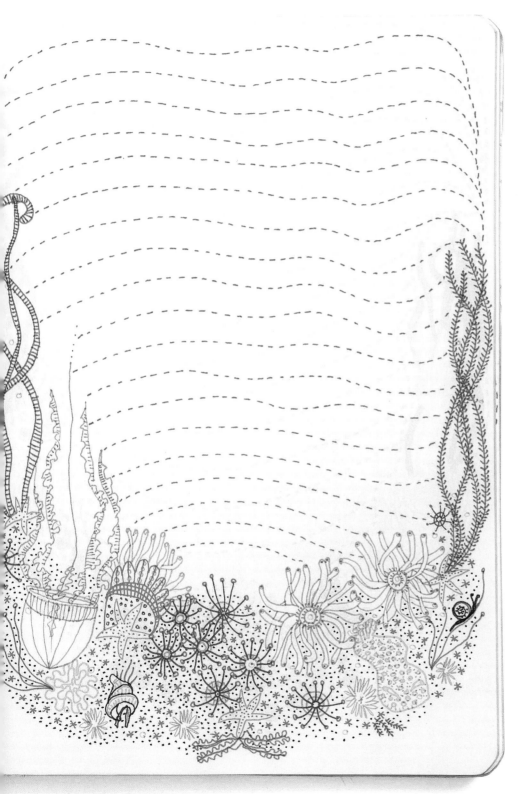

HOW MANY SKETCHBOOKS DO YOU HAVE, AND HOW OFTEN DO YOU RETURN TO OLD ONES?

I have two 2-foot (0.6 m) -wide shelves full of sketchbooks so far. I do return to the old ones quite often to reference ideas I want to use in new work. In the case of fire, these sketchbooks are the things I'd want to save the most!

HOW HAS NATURE BECOME YOUR MAIN INSPIRATION FOR YOUR ARTWORK?

I draw the world around me as a way to figure out how things are built or put together and how they relate to one another. The simple repeated shapes and components found in nature inspire me most, as do the colors of man-made items. I'm also really fascinated by the idea that everything is interconnected, that each is a piece of the greater whole, that each is the same as everything else, just on different scales. In my head, I envision the world and everything in it as "circles within circles."

wavy-leaved
soapplant
64

umbrella
plant 523

sierra primrose
521

DO YOU USE DIRECT REFERENCE FOR YOUR DRAWINGS, OR ARE THEY IMAGINED OR REMEMBERED?

Both. My drawings are like a conversation between myself and the object I'm depicting, so it's essential for me to start with a real object that I've experienced in person. Then I'll add a little of my imagination to my recording of it based on my experience with it or something similar, or I'll heighten an element or color I see in the actual thing. I've also learned how to take reference photos for myself that I can refer to later if I can't complete the drawing in the field, which is often these days. I have a hard time drawing directly from imagination or directly from photos—both result in images that are lifeless.

YOU ARE SUPER PASSIONATE ABOUT BEING ENVIRONMENTALLY CONSCIOUS. IN WHAT WAYS HAS THIS IMPACTED YOUR WORK?

I'm always reexamining the way I do things and the things I do and make in order to live as beautifully, simply, and efficiently as possible. I try not to add to the clutter on the planet just to satisfy my own ego, from using recycled or eco-friendly materials, to designing something the best it can be so people will want to buy and use it, to making only as many of the item as people will realistically buy, to finding ways to reuse or remake things if they don't sell. That's not to say I don't enjoy a bit of excessiveness now and again! I'm no fundamentalist.

e upatorium

eupator ium

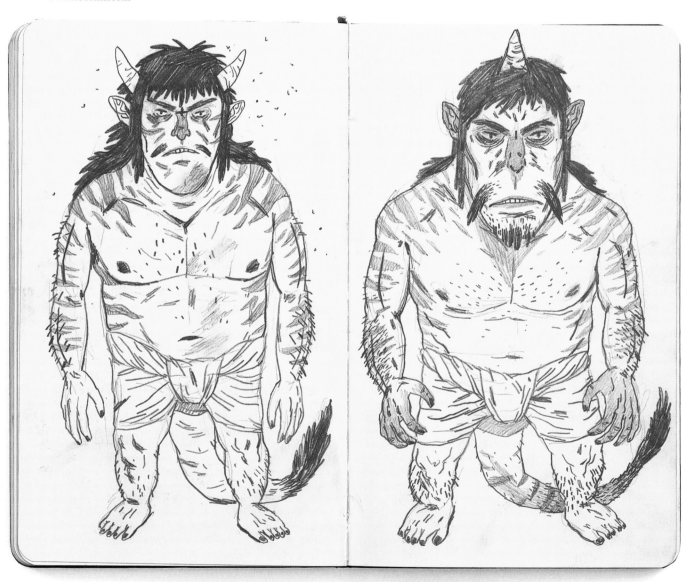

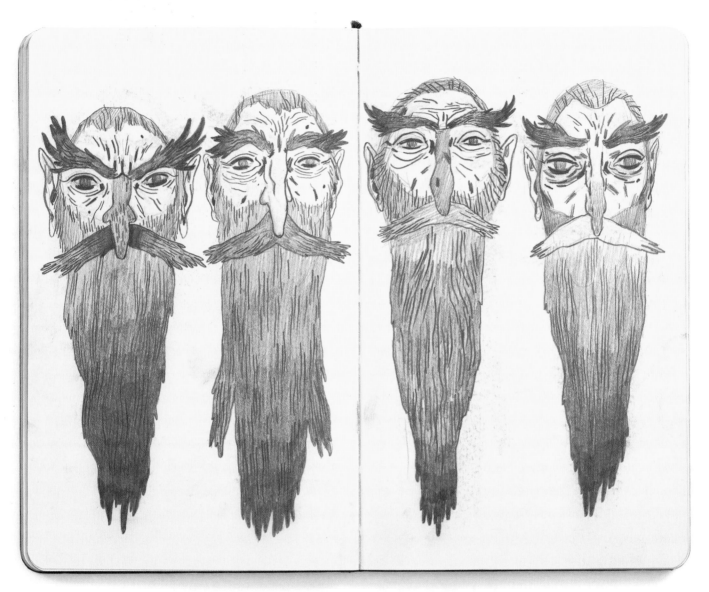

Sam Bosma graduated from the Maryland Institute College of Art in May 2009 and has been working mostly on editorial illustration since then. His end goal is to work in the book industry doing interiors or covers. He is part of *Picture Book Report*, a group blog where more than fifteen artists illustrate selections from some of their favorite books. He is illustrating twelve pieces based on *The Hobbit* by J.R.R. Tolkien. His clients include Plansponsor, *The New Yorker*, *The Stranger*, *Muse* magazine, and others. Sam currently lives, works, and eats candy in Baltimore.

YOUR SKETCHBOOK IS FULL OF ALL KINDS OF CREEPY CHARACTERS. ARE THESE STUDIES FOR PARTICULAR PROJECTS?

Most of these sketchbooks are full of designs for *The Hobbit*, which I've been working on illustrating for the *Picture Book Report* project. The ink sketchbook is mostly aimless, though I think there are some superheroes in there. I started actively using my sketchbook only recently as a way to keep my mind and hand working between freelance jobs. Aside from the work for *Picture Book Report*, all of the work in there is basically nonsense. I've never been one to sit down and draw something I've been thinking about. Images almost never formulate themselves fully in my mind before I draw them, or if they do, I can't hope to replicate them. Everything gets worked out on the page.

WHAT HAVE BEEN SOME OF THE CHALLENGES AND SUCCESSES THAT HAVE COME OUT OF WORKING ON *THE HOBBIT*?

Boy, it is difficult. I knew taking on *The Hobbit* would be a really difficult project because so much of the visual accompaniment is already so strong and so ingrained in the public consciousness. Alan Lee and John Howe basically crafted the *de facto* visual language for all of Tolkien's world and certainly for *Lord of the Rings*. *The Hobbit* is a very different story, tonally, and I thought that deserved exploration. I think there's a lot of room for a friendlier (but certainly not toothless) version of the fantasy epic, and I wanted to see what I could do with that concept. I think it's fairly successful so far, but I'm sure I'll have a more accurate opinion of it when I'm finished.

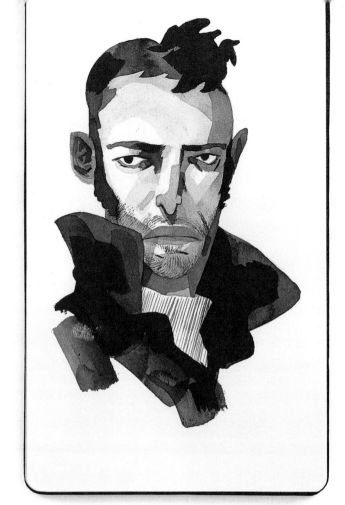

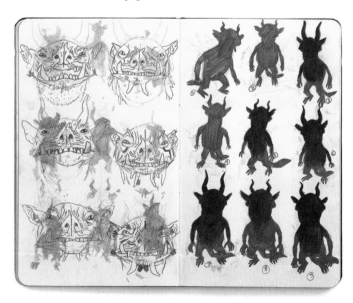

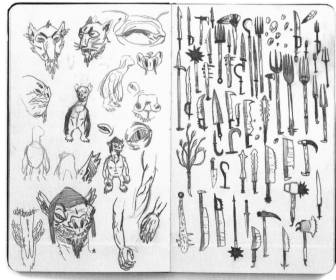

YOU KEEP A REGULAR BLOG ABOUT YOUR WORK, SHOWING LOTS OF IN-PROGRESS WORK AND SKETCHES. WHAT DO YOU ENJOY ABOUT POSTING THESE TYPES OF ENTRIES?

I became pretty serious about regularly updating my blog as an effort to make myself draw more. I think I made a daily post for about two or three months, and by the end of that time, I had formed some better habits concerning drawing and sketching. I started showing my process because I like seeing how people work and figured that desire wasn't too uncommon. Also, someone asked. As a student, I was often discouraged by all of the amazing art all over the Internet. It's so rare that those amazing people post their unfinished or unsuccessful work that it's easy to forget that everyone endures regular failure before crafting something good. I think I appreciate final work more if I see the process and see those troubles and those struggles.

IF YOU WEREN'T AN ILLUSTRATOR, WHAT OTHER PROFESSION WOULD YOU ENJOY? (IT SEEMS LIKE YOU WOULD MAKE A GREAT TEACHER!)

I'd love to be a teacher, and I hope I get that opportunity at some point. Realistically, I'd probably be a fiction writer. I wanted to be a paleontologist for a number of years, but that dream kind of fizzled when I found out how boring the majority of it actually is.

CALEF BROWN

Brunswick, Maine
www.calefbrown.com

Calef Brown has written and illustrated many acclaimed books for children, including *Polkabats and Octopus Slacks, Dutch Sneakers and Fleakeepers, Tippintown, Soup for Breakfast, Flamingos on the Roof,* and *Hallowilloween: Nefarious Silliness from Calef Brown.* His artwork has also appeared in numerous magazines and on book covers, billboards, and gallery walls. Calef lives and works in beautiful Maine.

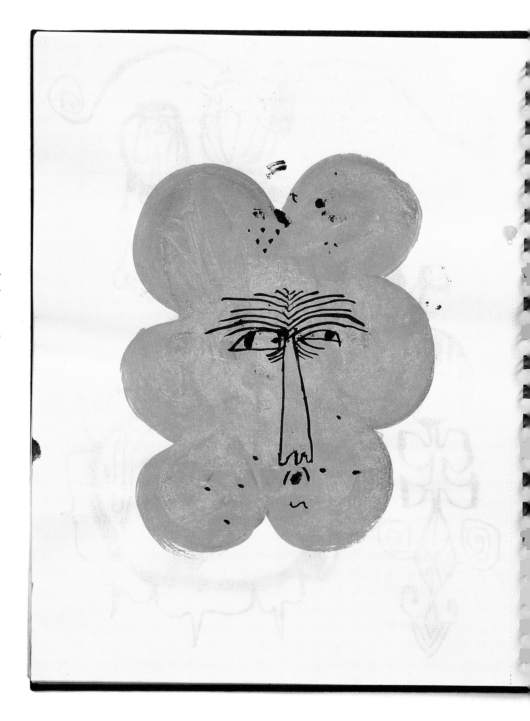

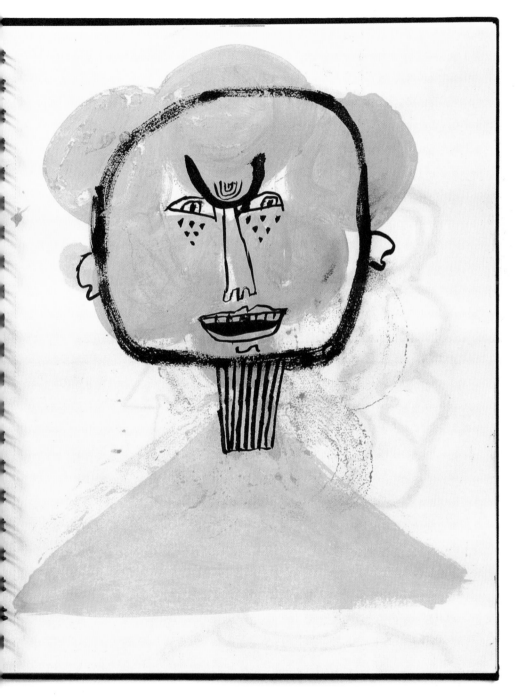

WHAT ARE THE MAIN FUNCTIONS OF YOUR SKETCHBOOKS?

Some of my sketchbooks are only for drawing and painting—experimentation and playing around. I have other sketchbooks that are mainly for writing and working on children's book ideas, but I draw in those, too.

WHERE DO YOU USUALLY SIT WHEN WORKING IN YOUR SKETCHBOOK?

Seems like it's a couch, either at my studio or at home.

HOW MANY SKETCHBOOKS DO YOU HAVE? WHERE DO YOU KEEP THEM?

I have, I'd guess, between fifty and seventy-five sketchbooks, but I've never counted them. I keep them on some shelves in my studio, and there are usually four or five lying around at home.

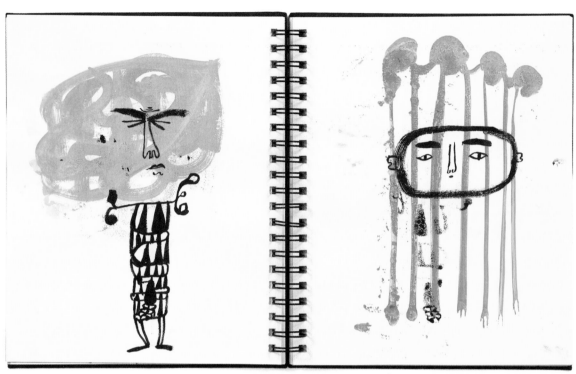

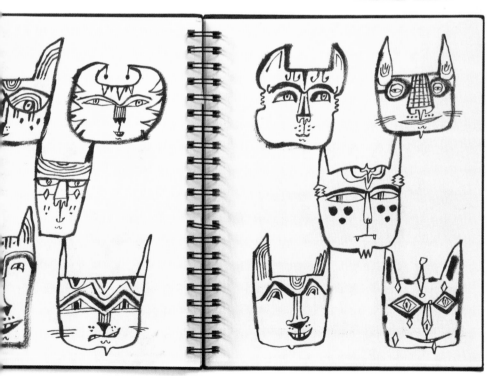

ARE THERE ANY PAGES THAT ARE ESPECIALLY SIGNIFICANT TO YOU?
Pages in my books where I'm first playing around with verbal and visual ideas that later become part of my children's books are really special to me, as are sketchbooks that I bring when traveling.

TAD CARPENTER

Kansas City, Missouri
www.tadcarpenter.com

Tad Carpenter is an illustrator and a designer living in Kansas City, Missouri. Tad has been lucky enough to work with clients such as Chronicle Books, Macy's, Target, *Anorak*, Atlantic Records, the Corcoran Gallery of Art in Washington, D.C., Simon & Schuster, *Family Circle*, Dave & Busters restaurant, Hallmark Cards, kidrobot, Ray-Ban, and MySpace, to name a few. Tad has illustrated and designed several children's books as well as spot illustrations and national campaigns in the current marketplace. He has been featured in *Communication Arts, Print Magazine, HOW, Graphis,* and dozens of publications in regard to design and illustration.

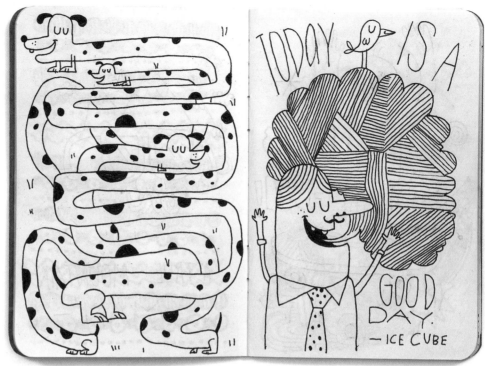

YOUR WORK GENERALLY FEELS VERY HAPPY. WOULD YOU SAY THAT'S A REFLECTION OF YOUR PERSONALITY?

I would say so. I am a pretty positive person. I love so much what we all get to do. I feel very lucky to be doing exactly what I have always wanted to do since I was five years old: draw, think, and design.

WHAT ARE YOUR FAVORITE COLOR COMBINATIONS?

I really love bright, unexpected colors with a rich chocolate of some sort: so, bright mustard yellow with brown or even a peach with brown. I love picking a safe color palette but then removing a color from that palette and inserting a color that would traditionally not be seen as a successful match and making it work.

I love making collages. I was working on a project several years ago with acetate pieces for a mock-up of a book design. I had a big pile of scraps on the floor of leftover pieces that just looked so amazing to me. I started collecting scraps from around the office that were printed on acetate or vellum or other transparent materials. I then just started to explore some mini compositions within my sketchbook. Some of the ones I have created in my sketchbooks have gone on to be screen prints, fabric, or textiles pieces—just a great way to have fun and explore.

ALL OF YOUR SKETCHBOOKS ARE VERY SMALL. WHY DO YOU LIKE USING BOOKS OF THIS SCALE?

I tend to use smaller sketchbooks for a couple of reasons, one being that they are so easy to take with you—to a meeting, on a plane, on a road trip, whatever. I seem to come up with some of the best ideas when I am away from the studio and just stuck with myself and my sketchbook. Another reason I enjoy smaller books is that I am not focusing on drawings that are necessarily finished. So working smaller allows me to actually feel a little more free and exploratory and to work fast. Most of these sketches and ideas at this phase are me working pretty quick so I can try and get as many ideas out as I can. Working smaller allows me to do this.

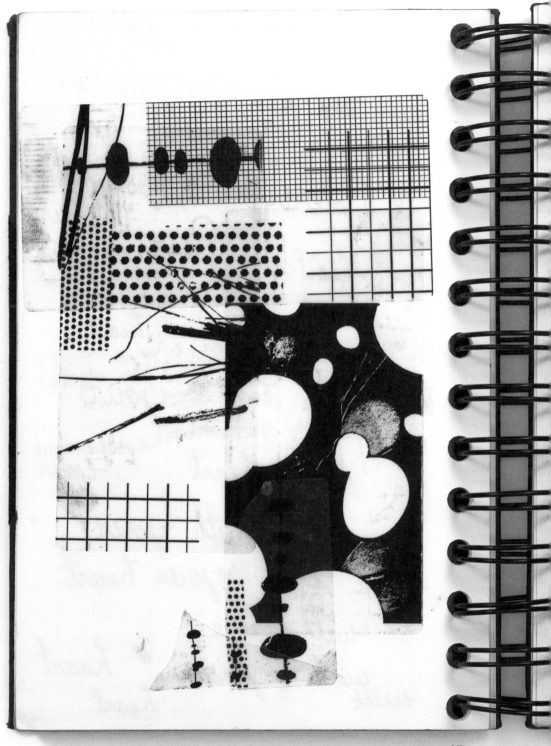

JEN CORACE

Providence, Rhode Island
www.jencorace.com

Jen Corace would rather be drawing than working a square job, would rather be eating toast than making a full-blown meal, would rather be walking and thinking than biking and nearly getting hit by cars, would rather be sitting and staring than playing kickball, would rather be sleeping than trying to make small talk, would rather be drinking coffee than water, would rather drink gin in the spring and summer and whiskey in the fall and winter, and would rather be a night owl than an early bird. She lives in Rhode Island. She has an amazing dog. She makes children's books and does gallery shows.

WHAT ARE THE MAIN FUNCTIONS OF YOUR SKETCHBOOKS?

My sketchbooks function as a catchall for my scattered, stop-and-go nature. I definitely have one or two that are all business. I recently managed to dedicate half a sketchbook to research and ideas on a body of work that deals with Nantucket Quaker women during the whaling era ... but that one is slowly fraying into chaos. Overall, my sketchbooks are used for me to scribble out ideas, lists, lists for more ideas, playing with pattern, playing with layers, working out shapes, using up extra paint, and more and more lists.

THE CHARACTERS IN YOUR ARTWORK ARE OFTEN LITTLE GIRLS. I AM CURIOUS WHO THESE GIRLS ARE AND IF THEY ARE BASED ON ANYTHING IN PARTICULAR.

In the beginning, at least in my head, my work was more narrative, and the girls carried these vague story lines along. Over time, they became more stoic, more still, and they feel more like me. Not that they are self-portraits, but I find more often than not that I am trying to stay still while trying to figure on what is going on around me.

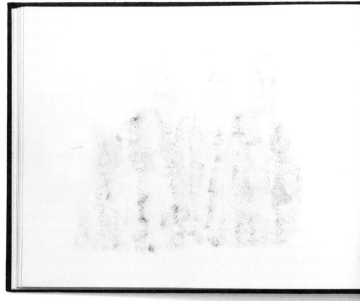

WHAT IS A TYPICAL WORKDAY LIKE FOR YOU?

I don't have a typical workday. I dream about having a typical workday, but I'm not very disciplined. Which is not to say that I don't have a good work ethic … it just doesn't have a form. I am actually a workhorse. Once I am in the swing of things, it's hard to get me to stop. Conversely, once I stop, it's hard to get me to start.

The basics though, involve me being a night owl and a procrastinator. I operate and think best at night. The later the better. I tend to get into my studio around 4 or 5 p.m. but then procrastinate until 8 or 9. Procrastination can include lying on the floor and staring at the ceiling, answering long-overdue emails, consulting reference books, looking for more reference books online, doodling, organizing, and cleaning. I can easily work until 3 or 4 a.m., but there are times that I have gone as late as 7 a.m., which is usually the only time I see 7 a.m. Again, it is sometimes difficult to get me to stop.

I NOTICED A LOT OF NATURE THEMES IN YOUR WORK … AND ALSO WATER. DO YOU THINK YOUR SURROUNDINGS, LIVING IN PROVIDENCE, HAVE INFLUENCED YOUR WORK?

There is a good mix of industrial and natural in Providence and throughout parts of Rhode Island. I'm always interested in plants and earth taking over man-made things, swallowing things whole over time. As for the water, my grandmother lived in Ocean City, New Jersey. I would spend my summers there, so the ocean has always been a factor in my life. I can't imagine being in a landlocked state. It creeps me out.

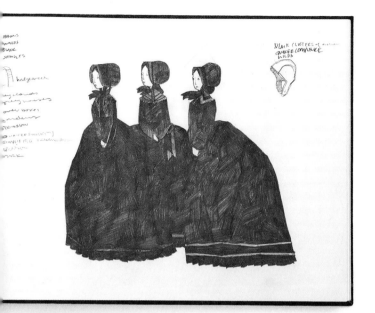

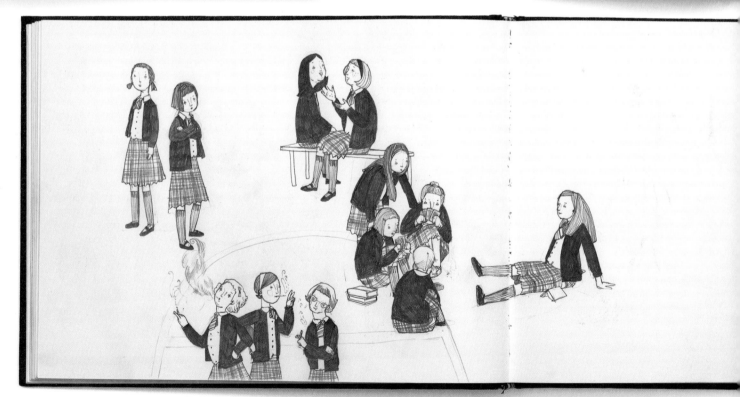

CHRISTIAN DEFILIPPO

Brooklyn, New York
www.chiristiandefilippo.com

Christian DeFilippo has been
making art all his life. He
studied art professionally at the
Rhode Island School of Design.
Originally from the Bronx, New
York, he has traveled and lived
in many places but currently
resides in Brooklyn. His work
is inspired by clip art, patterns,
dance parties, photography, and
the natural world.

WHAT ARE THE MAIN FUNCTIONS OF YOUR SKETCHBOOK?

For me, a sketchbook functions
as a way of experimenting with
new ideas and new material.
When working on a drawing
or painting, there can be that
feeling of pressure to make
something really nice. With
a sketchbook, it's more casual.
If you make something that
turns out bad, it's okay because
there are still other blank pages,
and besides, no one needs
to see it anyway because it's
your sketchbook.

DO PEOPLE EVER LOOK AT YOUR SKETCHBOOK? HOW PRIVATE IS IT?

People look at it. I stopped
writing down personal stuff a
long time ago so my sketchbook
isn't that private.

I LOVE THE PAGE WITH THE BALLOONS TAPED ONTO IT. HOW DID THAT PAGE COME TO BE?

I don't really remember. One of the nice things about keeping sketchbooks is that it provides a context where you can look at things as having artistic value. If someone is looking through your sketchbook and they see a balloon, or a flower, or whatever, then they're going to look at it a little bit harder than if it was just on the street or something. I'm always drawn to bright colors and the balloons probably caught my eye because of that. Then it was like, "Why don't I just make a page of balloons?" The next step is trying to figure out what goes on the adjacent page. In a way, my sketchbook habit has more in common with someone who does scrapbooks than with someone who is drawing everything around them in their book and not really worrying about how it will read when it's done.

I NOTICED THE UNIQUE BINDING. DID YOU MAKE THIS BOOK YOURSELF?

Yes. I learned bookbinding at RISD. For a while, I would make my own sketchbooks instead of buying them. I never got the hang of putting on a cover, so that's why the binding is exposed on the spine when you look at it. It has a practical function—if I really overload the book, there's a little more room for it to give.

43

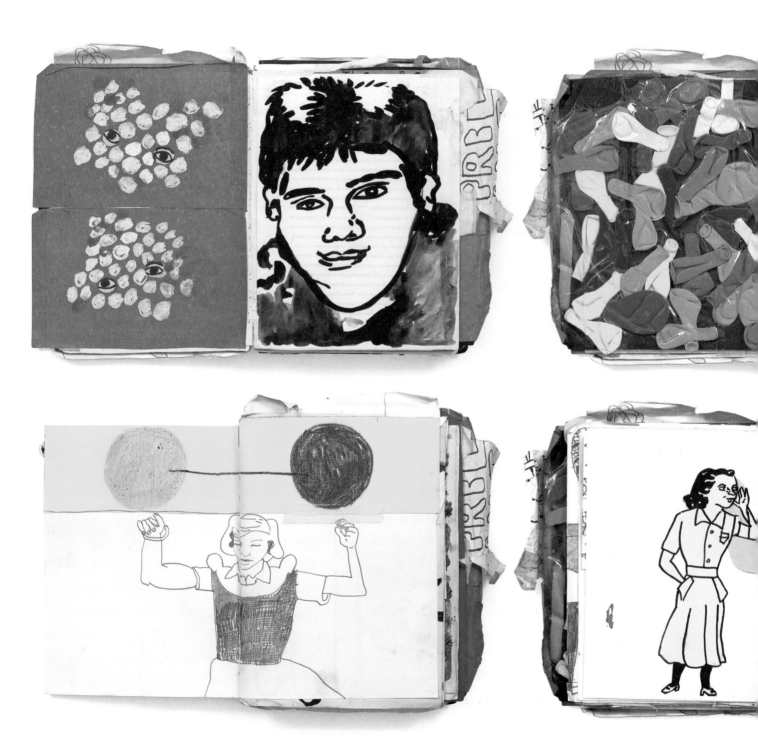

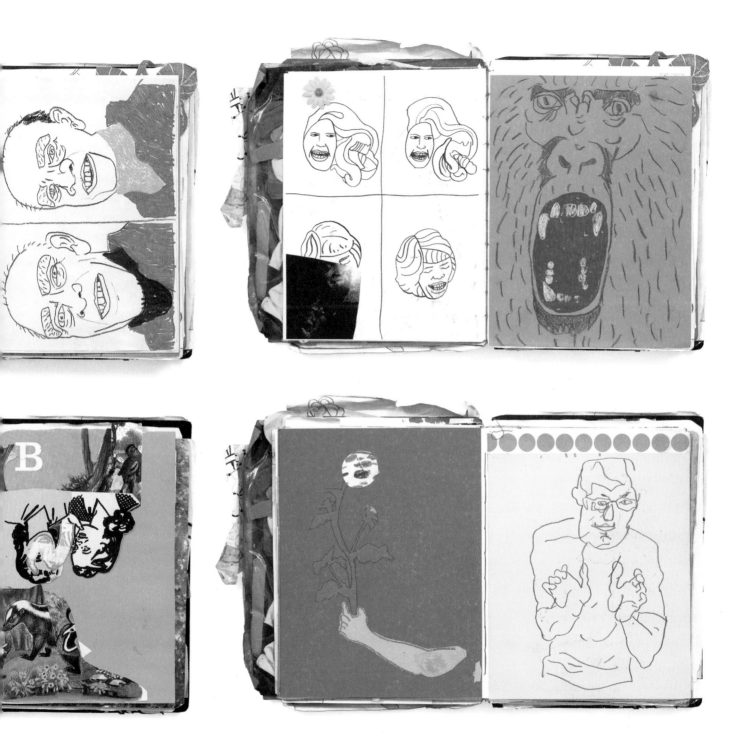

ROB DUNLAVEY

Natick, Massachusetts
www.robd.com

Rob Dunlavey was born in 1955 in Elgin, Illinois, and grew up near Chicago. In high school, he attended the Art Institute of Chicago and received a BA in fine art from Southern Illinois University. In 1984, he earned an MFA in sculpture from Claremont Graduate University, Claremont, California. Although he was trained as a fine artist, Rob has always enjoyed graphic arts and illustration in particular. He started freelancing for Boston–area newspapers in the mid-80s and has continued doing editorial illustrations for magazines. His early,

parallel interest in children's book illustration led to assignments in textbook publishing, online and CD-ROM products, and designing illustrations for children's museums. Rob's increasingly addictive habit of keeping sketchbooks has led to a renewed interest in children's book illustration as well as to gallery exhibits of his noncommissioned work. He is currently completing illustrations for Bayard Presse in France and is writing children's stories of his own.

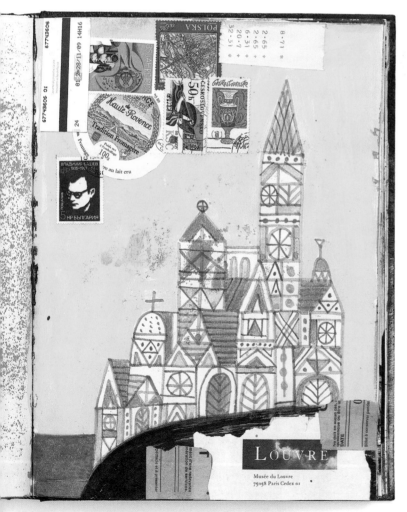

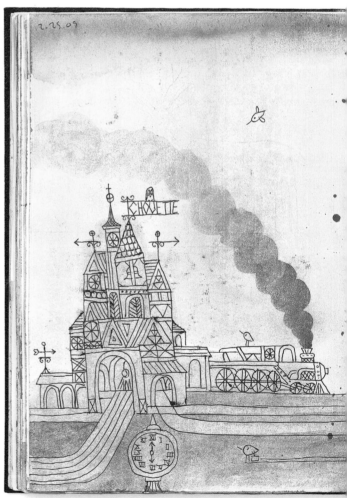

YOU'VE DONE A TREMENDOUS AMOUNT OF VARIATIONS OF WHAT YOU CALL "CRYSTAL CITIES." HOW MANY DRAWINGS AND PAINTINGS HAVE YOU MADE ON THIS THEME? WHAT INTERESTS YOU SO MUCH ABOUT THIS SUBJECT?

Crystal Cities evolved into a picture-making strategy in early 2009. I keep a few galleries of scans on my flickr blog. There are approximately 260 images in one of these galleries. Add in the doodles and Crystal Cities sculptures, the total number is somewhere between 300 and 350.

I am restlessly drawn to this basic castle-cathedral form. I like the interplay of formal elements (media, line, color, atmospherics, perspective, etc.). I like exploring images in series. It allows me to enjoy a subconscious kind of thought pattern as I just draw and respond, in the moment, to what is unfolding on the paper. It's a flow of reactions and decisions and hopefully, pleasant surprises. I also find them very relaxing to draw. Sometimes I'm just repeating myself, and then I try to do something different yet maintain the basic rules of the concept. Now, this is an answer that an artist would understand but I want to tell you also that these complicated, playful, emotional, and I feel life-enhancing images of cities and sacred structures are something I'd like to leave behind as evidence of my time on and appreciation of this beautiful planet.

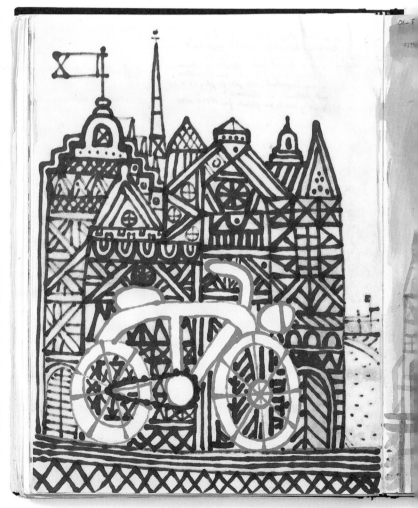

YOUR CHARACTER DESIGNS ARE OFTEN SO SIMPLE, JUST A FEW SHAPES, YET THEY ARE SO PLAYFUL AND HAVE A TREMENDOUS AMOUNT OF PERSONALITY. HOW ARE YOU ABLE TO DO SO MUCH WITH SO LITTLE? WHAT ARE THE IDEAS YOU KEEP IN MIND WHEN YOU ARE DESIGNING CHARACTERS?

The "doing so much with so little" comes from two impulses, I think: the first is to put a pair of googly eyes on any shape and you have a character with a face that has an emotional life for you to foster. How simple is that?! Second, I love creating derivations of my sketches with digital vectors (Adobe Illustrator or Macromedia's Freehand software). There was a time when computer memory and bandwidth were precious things, and it made sense to keep the artwork as lean as possible. This is partly behind the simplicity of my characters, too. I find limitations to be very liberating.

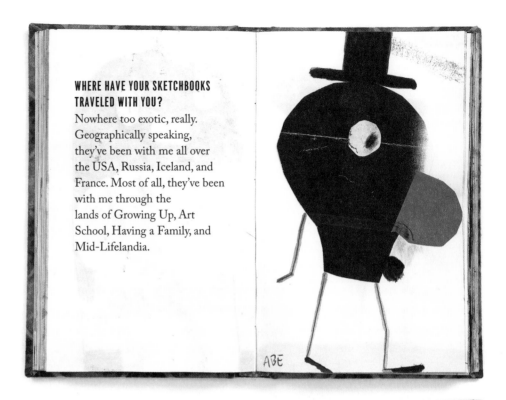

WHERE HAVE YOUR SKETCHBOOKS TRAVELED WITH YOU?

Nowhere too exotic, really. Geographically speaking, they've been with me all over the USA, Russia, Iceland, and France. Most of all, they've been with me through the lands of Growing Up, Art School, Having a Family, and Mid-Lifelandia.

HOW SIMILAR IS YOUR SKETCHBOOK WORK TO YOUR FINISHED ARTWORK? DO YOU USE THE SAME MEDIUMS OR WORK IN THE SAME WAY?

I think that all the art I'm doing now is a result of the sketchbooks that I kept during and after the time I spent in school. You can tell when you look at that sketchbook that a lot of those pages are added on over other ones. I did a lot of rearranging because I knew that some things would work a lot better on a page than others. In my studio, I keep lots of drawings and patterns, waiting for the right time to use them.

HOW DOES IT FEEL TO LOOK AT OLD SKETCHBOOKS?

This is a great question! Looking at old sketchbooks feels weird sometimes, and I don't go through them too much. Sometimes looking at sketchbooks brings on feelings of nostalgia. Once in a while, I want to find some very specific thing or remember what I was doing at a specific time. The sketchbooks are a record of my artistic and imaginative activity. Depending on my frame of mind, I sometimes can't stand how shallow some older sketchbooks seem. At other times, I'm extremely happy that I did the sketches because they've become something that I want to get back to and breathe new life into them.

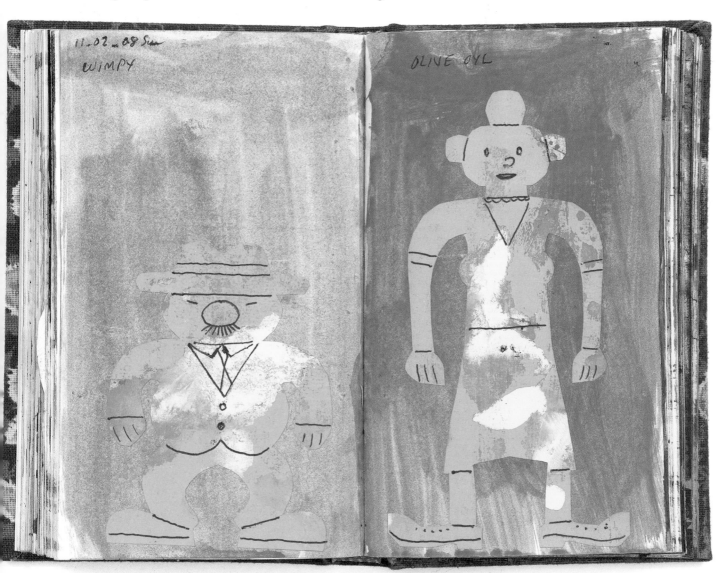

AUSTIN ENGLISH

Stockholm, Sweden
www.windycornermag-austin.
blogspot.com

Austin English is the author of
the books *The Disgusting Room*
(December 2010), and *Christina
and Charles.* He has also edited
three issues of the arts magazine
Windy Corner. All publications
are available from Sparkplug
Comic Books. He lives in
Stockholm with the artist Clara
Bessijelle.

**YOUR SKETCHBOOK IS ALL IN PENCIL.
WHAT DO ENJOY ABOUT DRAWING IN
PENCIL?**

The ease and simplicity. Since
these images are for myself, I
don't need to dress them up.

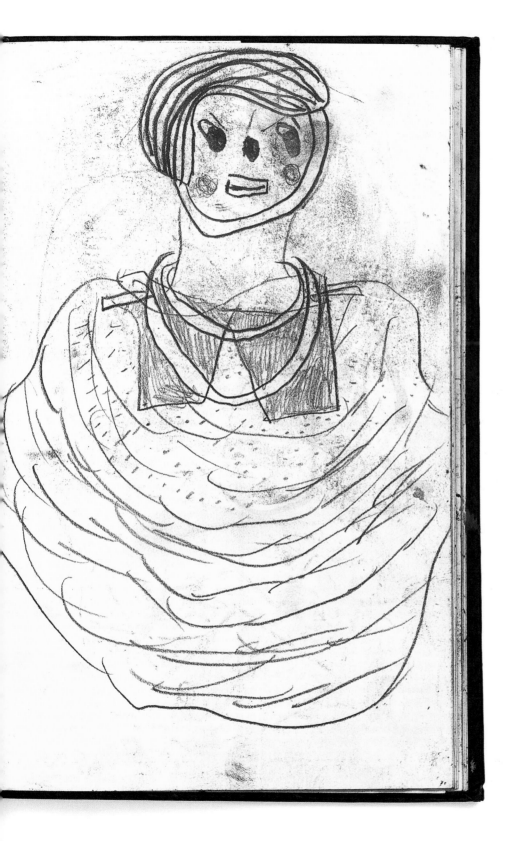

WHAT ARE THE MAIN FUNCTIONS OF YOUR SKETCHBOOKS?

While I try to be as free as possible in my work that's intended for publication, I struggle with self-conscious feelings about how odd my work is. In my sketchbooks, I can be free of this. I let my arm move across the page and make whatever shapes are rattling around in my brain. Sometimes those shapes become very important to me, and I try to bring them into my drawings that go into books. And sometimes moving my arm across the page in my sketchbook makes it easier for my arm to work in my comics.

HAVE YOU TRIED BIGGER SKETCHBOOKS?

For years I tried a different size sketchbook every time I bought a new one. But I've never been more comfortable with anything than this current one I keep buying over and over: digest size Daler Rowney. They have beautiful paper inside that is great for any kind of pencil (very smooth but somehow toothy as well) and the most simple (and elegant) design you can imagine. I recommend them to everyone.

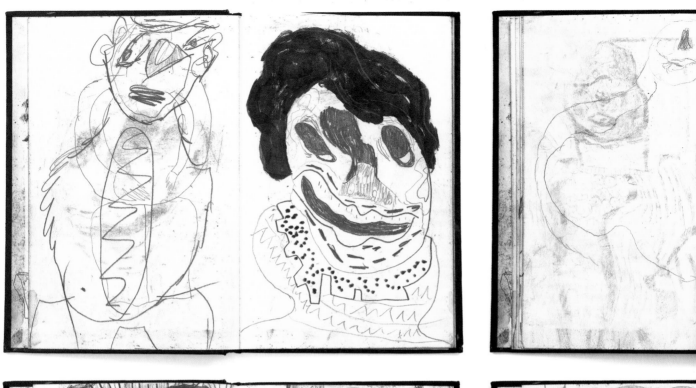

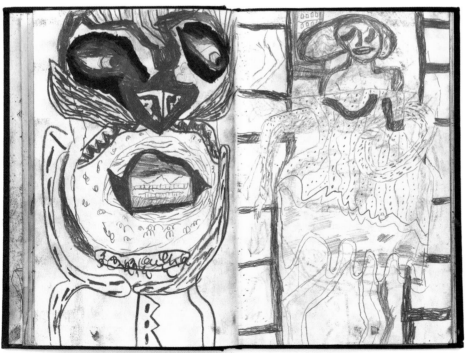

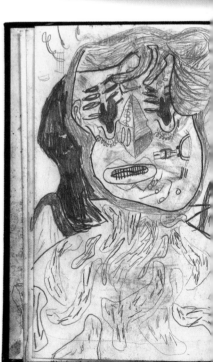

DO YOU REVISIT PAGES, OR DO YOU WORK UNTIL THEY ARE FINISHED?

I revisit pages a lot … this usually happens when I'm at a "drawing night" event. I have a hard time drawing at those kind of things, but sometimes I go for whatever reason. I always end up drifting to past pages and adding detail to them because it's hard for me to come up with new compositions in a crowd of people. I do most of my drawing with someone else in the room, but a crowd is another kind of thing. But it is good for that "adding detail" aspect. A lot of my favorite sketchbook pages are finished that way.

I NOTICED YOU RIPPED OUT A PAGE.

I rip out pages to give drawings to friends. And I do rip out pages I can't stand looking at anymore. But that's selfishly for my own benefit. I look at my sketchbook more than anyone else.

CAMILLA ENGMAN

Gothenburg, Sweden
www.camillaengman.com

Camilla Engman lives and works in Gothenburg, Sweden. She received her MFA degree from the School of Design and Crafts at the University of Gothenburg. Currently, she is taking at least a year off from being an illustrator to focus on creating fine art.

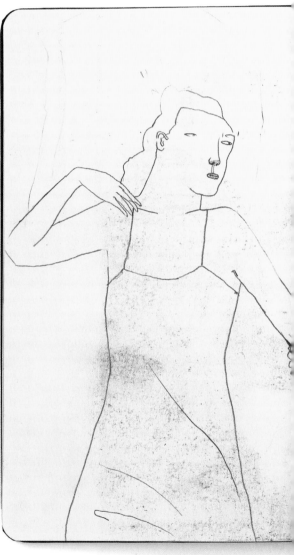

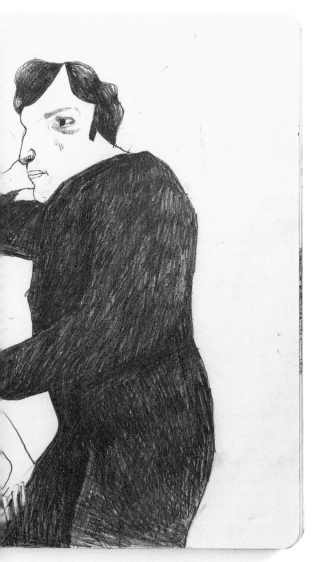

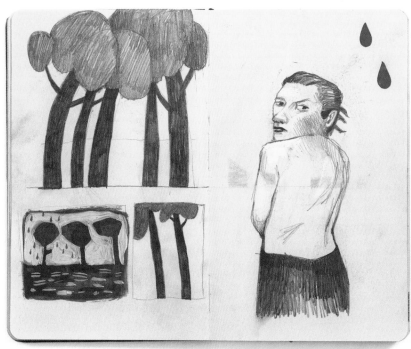

55

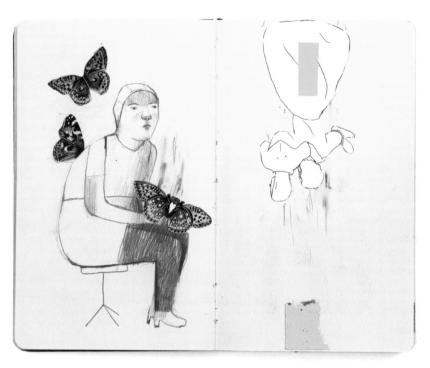

HOW DO YOU THINK GROWING UP IN TROLLHÄTTAN, SWEDEN, HAS INFLUENCED YOUR WORK?

It feels like that is like asking how my childhood has influenced my work. It's very hard to tell how since I can't compare with anything. Of course it has influenced my work and myself a lot. I grew up in a working-class family in a working-class area. I didn't know that then; it wasn't until I moved to Gothenburg and went to art school that I became aware of it. You know when you tell a story about something from your childhood; you think it's normal and funny until you see your new friend's horrified expression.

YOU SEEM TO LIKE TO COLLECT A LOT OF FOUND OBJECTS AND PAPERS TO INCORPORATE INTO YOUR WORK, GIVING THEM A NEW LIFE. HOW DO YOU FIND AND CHOOSE THESE THINGS?

I've found that almost everything looks interesting if you just look at it carefully enough. It is easier for me to see things that I'm not too familiar with. Therefore, many of my finds come from trips abroad.

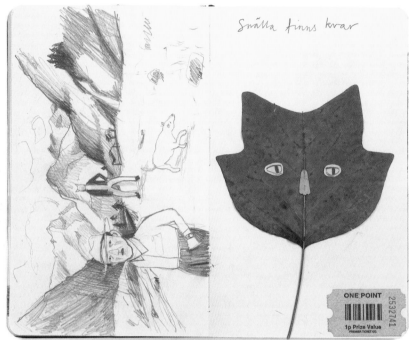

Snälla finns kvar

ONE POINT
2532741
1p Prize Value

HOW MUCH OF YOUR SKETCHBOOK WORK IS PREPARATION FOR LARGER PAINTINGS?

I guess everything I draw is preparation for paintings or other work. I sketch to find something or to solve a problem. I sketch to remember or to just try something out.

A LOT OF YOUR IMAGERY IS VERY SURREAL. WHAT ARE SOME OF YOUR INSPIRATIONS FOR WORK OF THAT NATURE?

I think life is surreal. Nothing is stranger than life. Two other things I find inspiring are the Web and a good film.

YOUR CHARACTERS OFTEN SEEM MELANCHOLY. IS THERE A PARTICULAR REASON THAT YOU LIKE TO DRAW PEOPLE IN THIS MOOD?

I just draw; I don't think, "Now I will draw a melancholy person." I try to set my brain in a neutral mood—to not think so much, to feel. I think I have a melancholy keynote.

BEN FINER

Brooklyn, New York
www.benfiner.com

Ben Finer was raised in the rolling Green Mountains of Vermont. His youth was spent collecting rocks, bottles, bugs, snakes, and bits of rusted metal he dug out of his backyard. He read comics. He ate bagels. He clawed at dirt. From 1998 to 2002, Ben attended the Rhode Island School of Design, where he received his BFA in painting. In May 2009, he earned his master's degree from Parsons The New School for Design. He currently lives in Brooklyn, New York, and continues to claw at dirt when he finds opportunity.

WHAT ARE THE MAIN FUNCTIONS OF YOUR SKETCHBOOKS?

My sketchbooks are mostly for sketching. Also, on occasion, I trap small beetles and use the covers of my sketchbooks to stage elaborate gladiator wars. I make the armor myself out of lint and bottle caps and beard trimmings. I don't consider this cruel because in the end, the beetles often refuse to fight and scuttle away with a relatively detailed suit of armor. From my sketchbooks I've learned you can never trust a beetle.

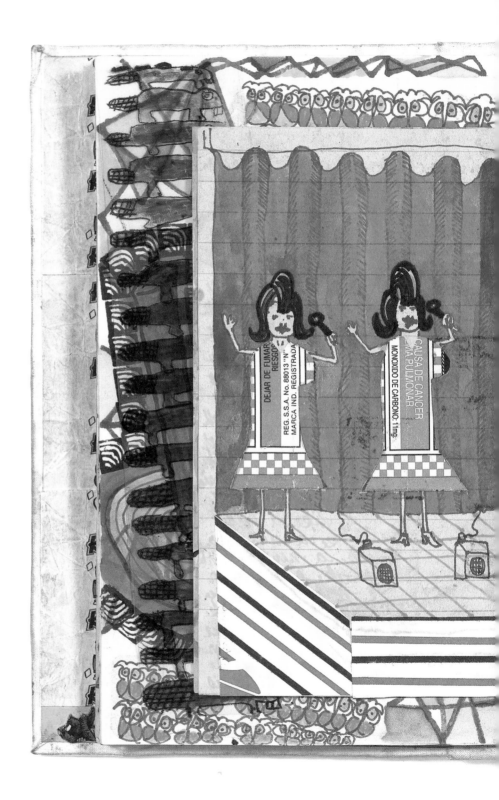

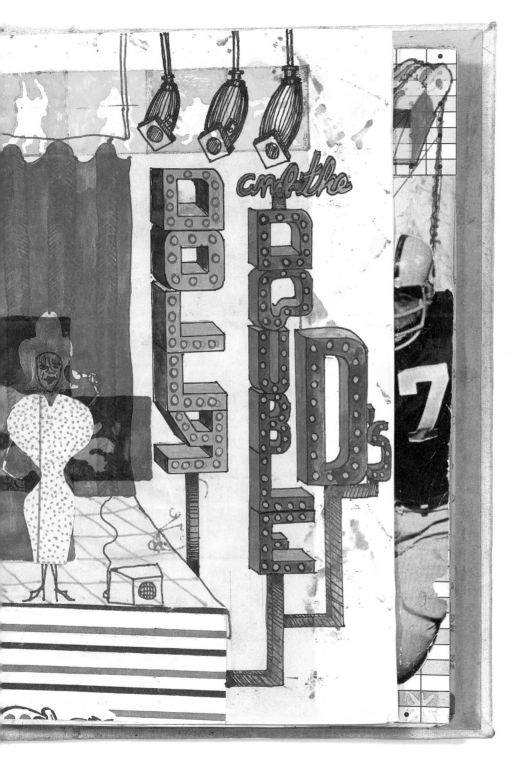

HOW OFTEN DO YOU WORK IN YOUR SKETCHBOOK?

I have no set schedule. Except on Wednesday nights when I head to Sunset Park to watch the cock fighting. I can usually do a pretty good job of picking a winner. I used to select the rooster with the most interesting name. This one time I chose Diego San Rafa de los Madres Salvajes de la Chingada de Dios. He was not a good fighter but had the fanciest name I had ever encountered at the fights. He lost very quickly. After that incident I did some real soul searching and came to a few very important decisions. Now I choose the biggest rooster or the best fighter. I hate losing money. If there's a rooster named Richie Martinez, I bet on him.

HAVE YOU NOTICED RECURRING THEMES IN YOUR SKETCHBOOKS?

Pigs, vomit, intestines, pigs vomiting, parts of the body, things in nature, piles, shapes, cacti, hives, veins, betrayal, seduction, the heart-wrenching burn of lost love, stories from classical Belarian literature, German proverbs, fingers, insects, devices, technical texts from outdated *Popular Mechanics* magazines, Popeye.

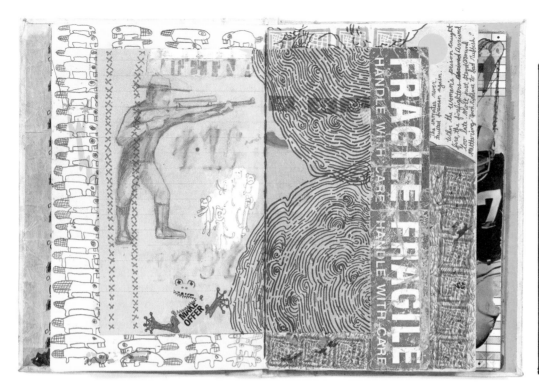

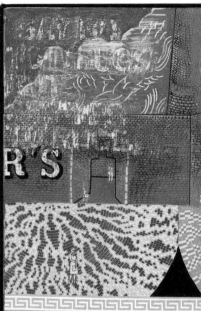

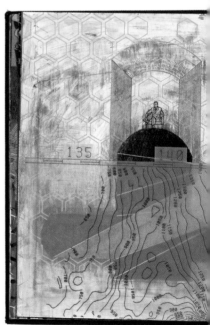

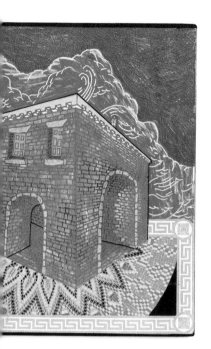
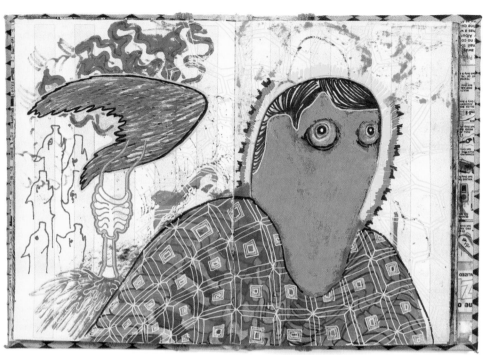
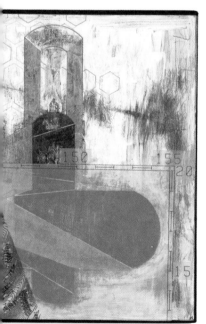
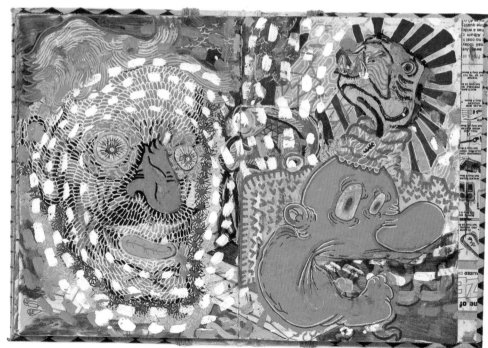

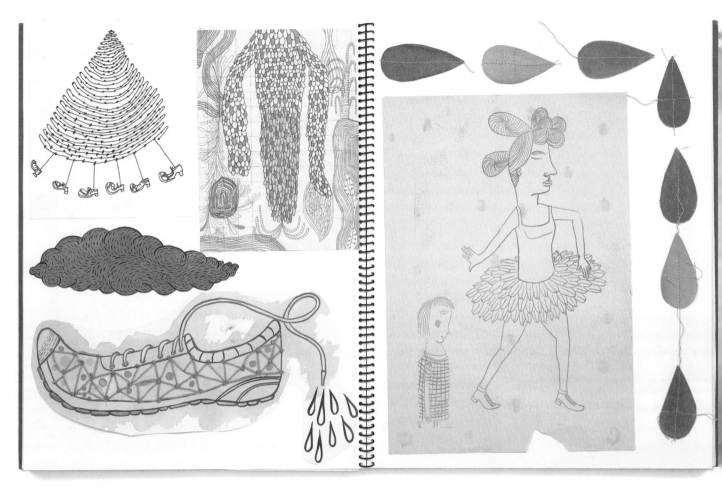

SARAJO FRIEDEN

Los Angeles, California
www.sarajofrieden.com

Sarajo Frieden is an artist and illustrator whose work is frequently seen on cards, books, bags, and bedding, as well as gallery walls from Melbourne to London to Rome. She loves to travel and has carried many a sketchbook with her on far-flung journeys. She lives in Los Angeles with her son (and the occasional wayward cousin) and likes to spend time in the ocean. She may have been a merperson in a previous life.

AS AN ILLUSTRATOR, YOUR WORK IS OFTEN NARRATIVE, AND IT SEEMS TO BE SOMETHING YOU DO OUTSIDE OF YOUR PROFESSIONAL ARTWORK AS WELL. IS THIS SOMETHING THAT HAPPENS NATURALLY, OR IS IT SOMETHING YOU ARE CONSCIOUS OF ADDING TO YOUR WORK?

My personal work can include embedded narratives, but I also like to work more abstractly. There are stories in the abstract work, too. I work more or less intuitively. Dialogues spring up from the process of making the work. I don't like to plan. For me, the whole point is the surprise, arriving at a place you never expected. Whether working more figuratively or abstractly, I ideally want the viewer to bring his or her own story, and for everyone it will be different.

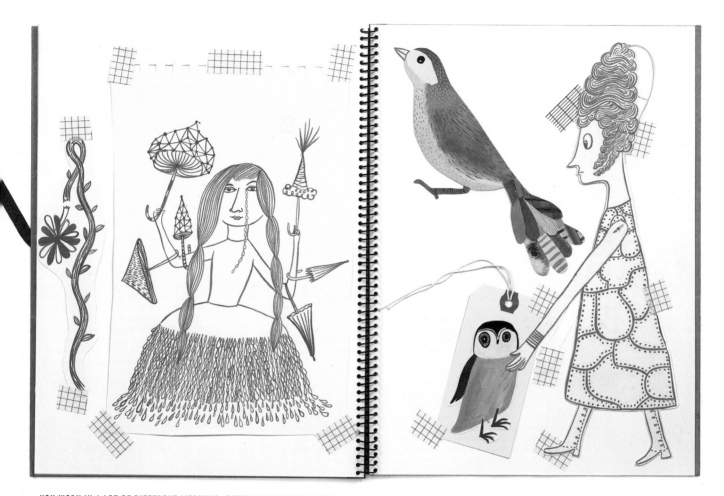

YOU WORK IN A LOT OF DIFFERENT MEDIUMS, OFTEN MAKING SURPRISING COMBINATIONS. FOR EXAMPLE, I'VE SEEN PAINTINGS THAT YOU'VE EMBROIDERED ON. WHAT ARE YOUR FAVORITE COMBINATIONS OF MARK MAKING? AND WHAT DO YOU LIKE ABOUT USING MULTIPLE MEDIUMS?

For a long time I worked exclusively in gouache, but I like layering, so lately I've been working with fluid acrylics. Paints and materials have different personalities, and it's interesting to switch it up and explore a wider vocabulary to see what happens. I still work mostly on paper, a medium I love for its spontaneity and the fact that you can cut up what you don't like and add it to something else.

As for embroidery, my grandparents had an embroidery business. I've been looking at textiles and embroidery since I was a little girl. My great aunt was a fabulous tailor who sewed all of my mother's clothes when she was growing up and many of mine as well! I like bringing something dimensional into my work on paper. Also, I've been collaborating for a number of years with Marci Boudreau—pieces go back and forth between us, with Marci doing embroidery while I draw, paint, or collage.

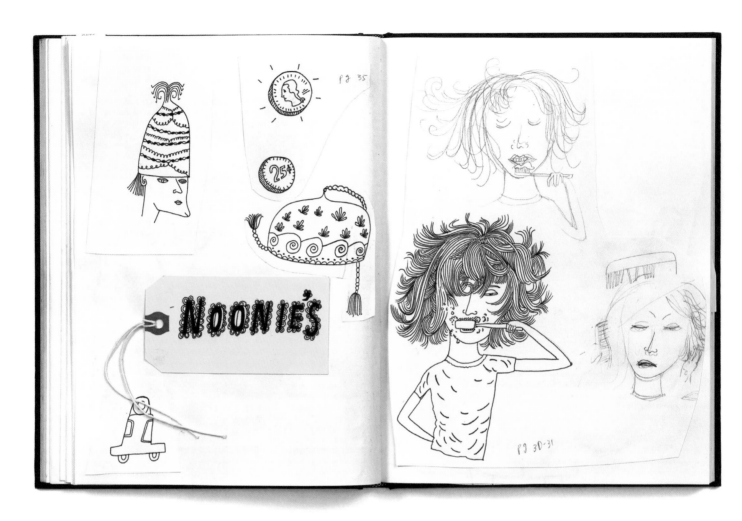

I NOTICED YOU TAPE A LOT OF DRAWINGS INTO YOUR SKETCHBOOK. IN A WAY THEY ACT AS SCRAPBOOKS AS WELL. WHERE ARE THESE TAPED-IN DRAWINGS FROM? HOW DO YOU DECIDE WHAT TO SAVE?

I'm always afraid of losing sketchbooks while traveling (it has happened before!), so I tend to bring sketchbooks with very few drawings in them. Over the years, that has meant a lot of half-finished sketchbooks, so I started going through and editing them, then compiling the pieces into new books. This process is interesting, too; going back and looking over work that might be three or five or ten years old—how does it relate to other pieces or what I'm working on now?

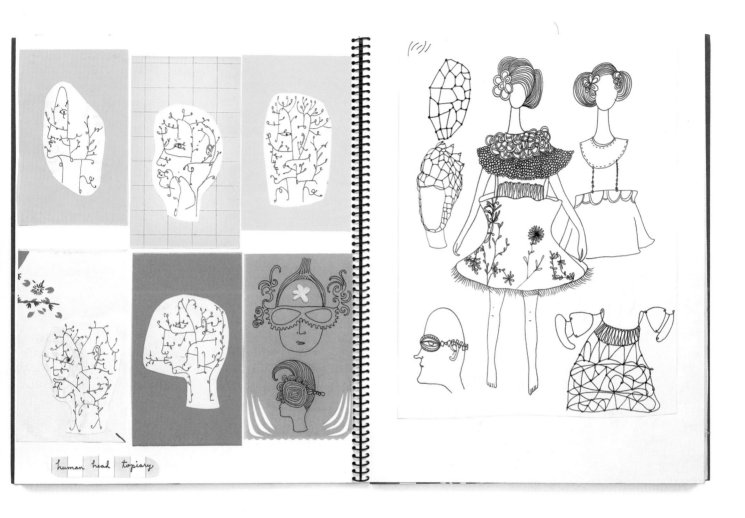

human head topiary

WHAT ARE SOME OF THE PLACES YOUR SKETCHBOOKS HAVE TRAVELED WITH YOU?

I have taken sketchbooks to the Galapagos Islands, Belize, Italy, Peru—basically, I take a sketchbook with me when I go to a local café. Traveling on the trains in Japan was a great place to draw people. The train rides were smooth and everyone seemed to be asleep, affording the opportunity of many cooperative models. A sketchbook is a nice way to paste in little papers you find—tickets, napkins. In the various temples in Japan they would stamp my sketchbook with their unique imprint. Perhaps a sketchbook, and drawing itself, is a way to slow down and absorb a new place you are visiting, without rushing around trying to see everything.

ABBEY HENDRICKSON

Apalachin, New York
www.aestheticoutburst.blogspot.com

Abbey Hendrickson lives very happily in upstate New York with her husband and their two babies. She earned her MFA in visual studies from the University at Buffalo and in the wee hours, writes a blog called *Aesthetic Outburst*.

YOUR SKETCHBOOKS ARE SO DIFFERENT FROM EVERYONE ELSE IN THE BOOK. CAN YOU TELL ME ABOUT THEM AND WHAT INTERESTS YOU IN WORKING THIS WAY?

I was making really giant drawings that were taking way too long to finish. The books acted as a faster way to work out compositions that I could then translate on a much larger scale. At the time, I was also teaching bookmaking classes and was trying to reteach myself certain bindings before class so I didn't look like a complete ass in front of my students (any amount of preparation on my part rarely solved that problem).

THEY ARE ALL SMALL SCALE. HAVE YOU TRIED MAKING BIGGER BOOKS?
I've made bigger books in the past, but I've never been very happy with them. They always look so clunky. I prefer the intimate scale; there's something great about a book that fits in the palm of your hand.

HOW MANY OF THESE BOOKS HAVE YOU MADE?
About a hundred.

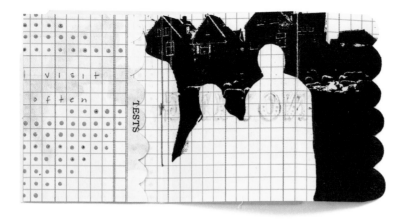

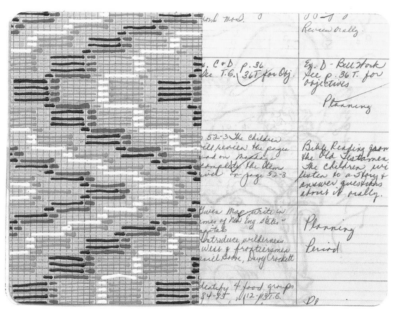

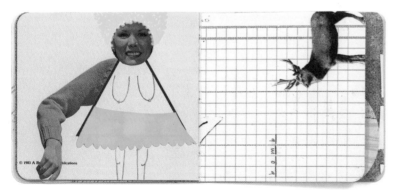

HOW LONG DOES IT USUALLY TAKE YOU TO MAKE ONE OF THESE BOOKS?
I used to set a time limit of one hour per book, which proved to be quite challenging. I ended up making a lot of crappy books, so I expanded my time limits. My favorite part about making art is getting lost in it, those moments when you don't realize how much time has passed. I think it feels a lot like going to a movie theater during the day; you know, when you emerge from the dark theater and the sun's still shining … fabulous.

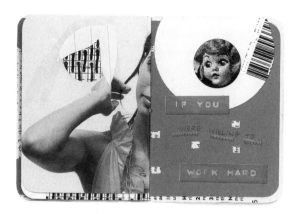

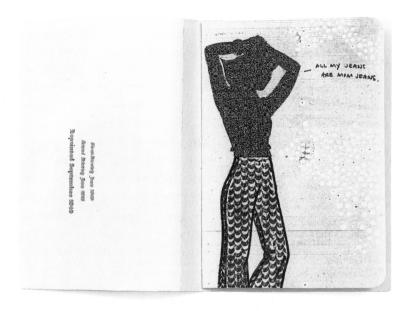

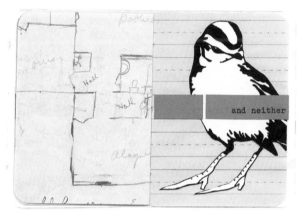

DO THE BOOKS HAVE THEMES?

In general, my work is about the dynamics of interpersonal relationships and passive aggression. What that really means is that I've based a whole body of work around remarks my mother-in-law makes at family functions. Call it a coping mechanism, but there's something I genuinely love about a comment that appears sweet but has a salty underbelly—the kind of comment that smacks you hard on the back of your head as you're walking away. Comments like that require a certain talent. Most of the books include one or two choice remarks; one of my favorites was, "Your hair could be your best feature … if you worked really hard."

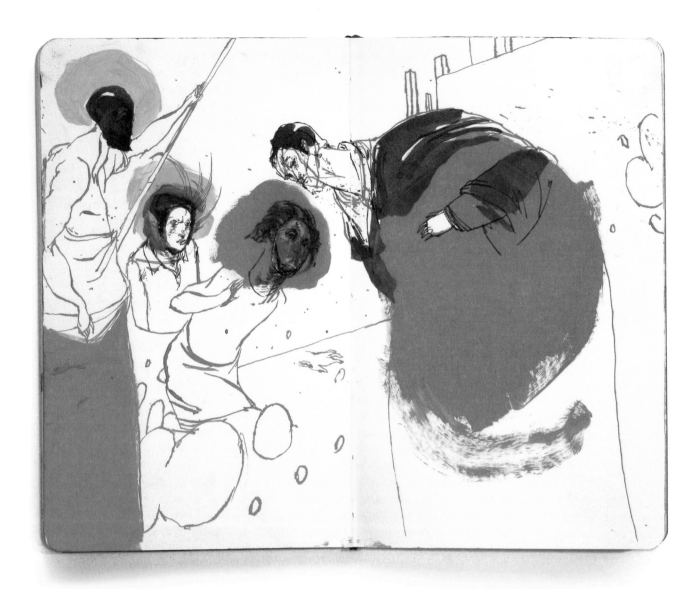

LARS HENKEL

Essen, Germany
www.reflektorium.de

Lars Henkel was born in 1973 in Rome, Italy; studied illustration at Aachen University of Applied Sciences (Germany); and graduated from the Academy of Media Arts in Cologne. He currently works as an illustrator and a lecturer at the Folkwang University of the Arts in Essen, Germany. Lars has been awarded several prizes, and his work has received recognition from the Society of Illustrators, *American Illustration, Communication Arts,* and *3x3.*

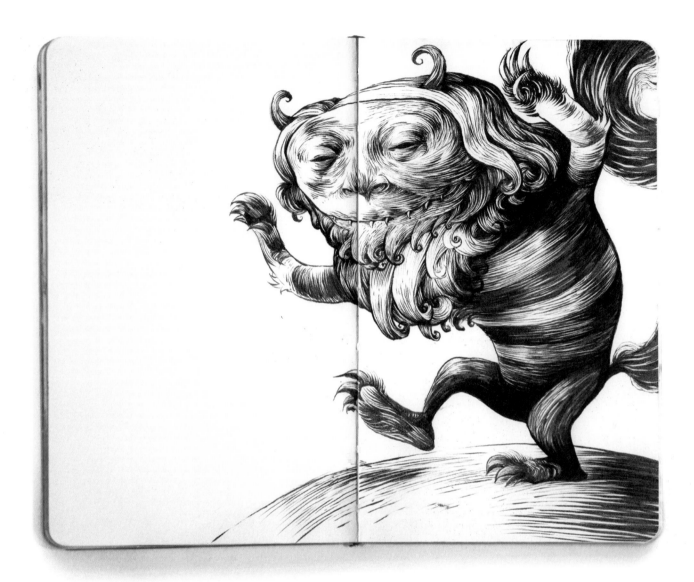

WHAT ARE THE MAIN FUNCTIONS OF YOUR SKETCHBOOKS?

I use my sketchbooks in different ways: for practicing drawing, of course; for visual experiments; for collecting interesting footage; and for developing ideas, images, and stories.

I LOVE THE DRAWING YOU DID OF A CHARACTER FROM WHERE THE WILD THINGS ARE. WHAT DO YOU LIKE ABOUT THAT BOOK?

Where the Wild Things Are is a special book to me because it is connected to early childhood memories. I discovered the book in kindergarten, and I was fascinated by its monsters and atmosphere. And thirty years later, I still have the desire to take the book off the shelf from time to time.

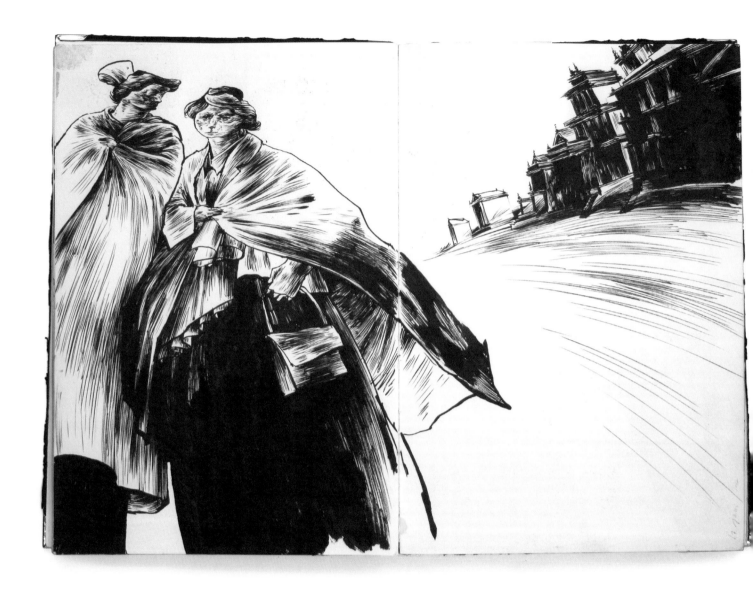

DO YOU REVISIT PAGES, OR DO YOU WORK UNTIL THEY ARE FINISHED?

I don't revisit pages very often. I go on when a page is finished. It's not important that every page look perfect. But ugly pages in between have to be reworked until they don't bother me anymore. And really terrible drawings have to be buried under layers of paint.

ARE THERE ANY COLORS THAT YOU TEND TO FAVOR IN YOUR WORK?

Besides gray pencil and black ink, I occasionally fill pages with every kind of orange. This color looks especially beautiful on a cream-colored paper.

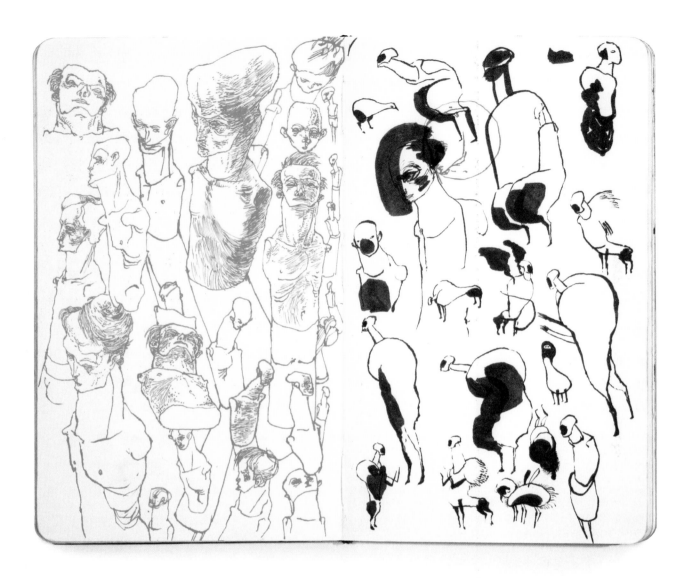

IS THERE A SPECIFIC TYPE OF BOOK YOU PREFER? A SPECIFIC TYPE OF PEN OR PENCIL?

For some years I have used the same size books (24 x 34 cm [9 ½ x 13 ½ inches]) that are sold by an art supply store in Cologne. Most of the time I draw with a mechanical pencil, a Rotring drawing pen, and a Pentel brush pen. The average amount of time I spend filling one of these books is one year.

JESSICA HISCHE

Brooklyn, New York
www.jessicahische.com

Jessica Hische is a typographer and an illustrator working in Brooklyn, New York. After graduating from Tyler School of Art with a degree in graphic design, she worked for Headcase Design in Philadelphia before taking a position as senior designer at Louise Fili Ltd. While working for Louise, she continued developing her freelance career, working for clients such as Tiffany & Co., Chronicle Books, and the *New York Times.* In September 2009, after two and a half years of little sleep and a lot of hand lettering, she left Louise Fili to pursue her freelance career. Jessica has been featured in most major design and illustration publications, including *Communication Arts, Print* magazine, *HOW,* the *Graphis Design Annual, American Illustration,* and the Society of Illustrators. She was featured as one of *Step* magazine's 25 Emerging Artists, *Communication Arts* "Fresh," *Print* magazine's New Visual Artists 2009 (commonly referred to as *Print's* 20 under 30), and the Art Director's Club Young Guns.

WHAT IS YOUR PROCESS FOR DRAWING OR BUILDING YOUR LETTERS? DO YOU SKETCH THEM OUT BY HAND AND THEN SCAN AND TRACE THEM IN THE COMPUTER? OR DO YOU OFTEN WORK DIRECTLY ON THE COMPUTER?

I pretty much always work directly on the computer. I hardly ever trace from my sketches. The only time I really use my sketches is if I've attempted to draw straight on the computer but somehow the character I captured in my sketches isn't coming across. This is especially true for things that are meant to look like handwriting (especially men's handwriting, which is the hardest of all things to draw, in my opinion).

YOU ARE ALSO A TALENTED ILLUSTRATOR. HOW IMPORTANT IS IT TO HAVE A GOOD FOUNDATION IN DRAWING TO BE ABLE TO DESIGN INTERESTING LETTERING?

Like any art form, having a good understanding of composition and balance is extremely important. When I work with students who have never done lettering before, the main thing I try to communicate to them is that type is no different from illustration. It's just an illustration that you can read. You should look at type as image rather than look a it as language.

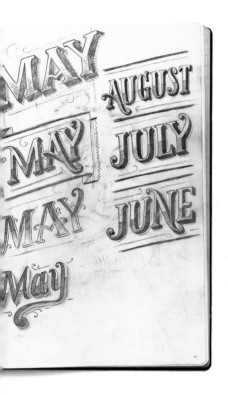

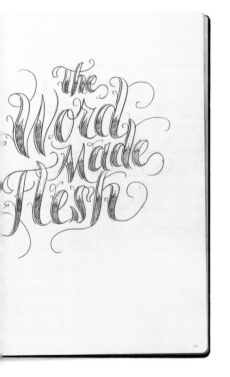

ARE THERE SPECIFIC TIME PERIODS YOU PREFER TO REFERENCE FOR YOUR LETTERFORMS? IF SO, WHERE DO YOU GET INSPIRATION FOR THESE?

It's hard to say where I get my specific references because most of my references were hardwired into my brain when I was working for Louise Fili. When I was in college, I loved '50s lettering, but my tastes seem to skew earlier and earlier as I go on. I love type from the 1930s and '40s (it's similar to the '50s sometimes but a bit less zany), and I love Victorian type of the late 1800s and early 1900s. When I need something to be very specifically referenced, I usually search online for a good reference or go shopping for new type books. There are more and more compendiums of type available for purchase, so you don't always have to rely on finding the perfect vintage book at a flea market or spending $500 (£324) on eBay.

HOW DOES IT FEEL TO LOOK AT YOUR OLD SKETCHBOOKS?

It's fun to look at them because my very old sketchbooks (high school and college) were so insanely detailed. I used to throw away sketchbooks if I messed up one page because I was obsessed with them being perfect containers of art. Now my sketchbooks are everything from notepads for taking art direction dictation to brainstorming lists, to doodles while on the phone, to intensely detailed type drawings. I do wish I drew more for fun, but I think I just have too wide a range of interests when it comes to spending my spare time.

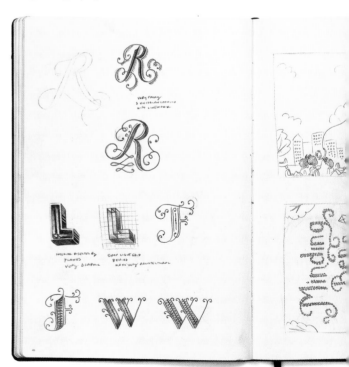

KATY HORAN

Austin, Texas
www.katyart.com

Katy Horan's work combines her interests in female costume history, folklore, fantasy, and all things spooky. She grew up in Houston, Texas, and received her BFA from the Rhode Island School of Design in 2003. Since then, her work has been shown in galleries across the United States and in Canada and has been published in art books such as *The Exquisite Book* and *Beasts!* as well as publications such as *Juxtapoz* and *New American Paintings* (October 2010). She lives and works in Austin, Texas, where she enjoys riding her bike, baking, and hanging with her dog, Obi Wan Kenobi.

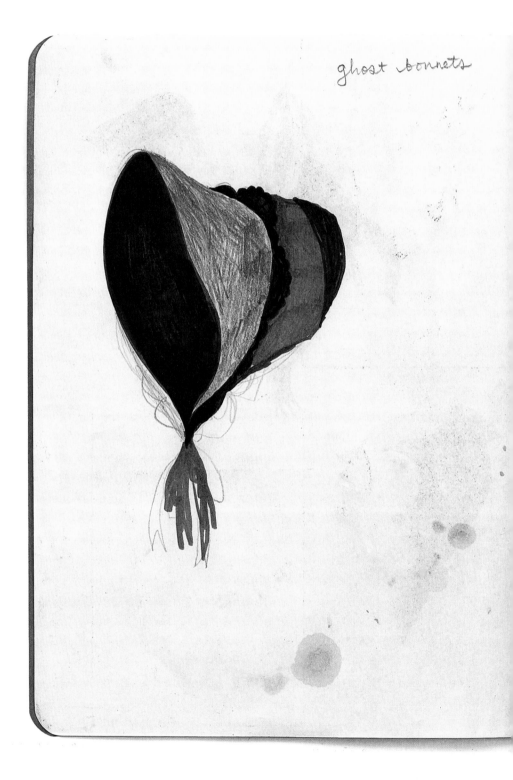

ghost bonnets

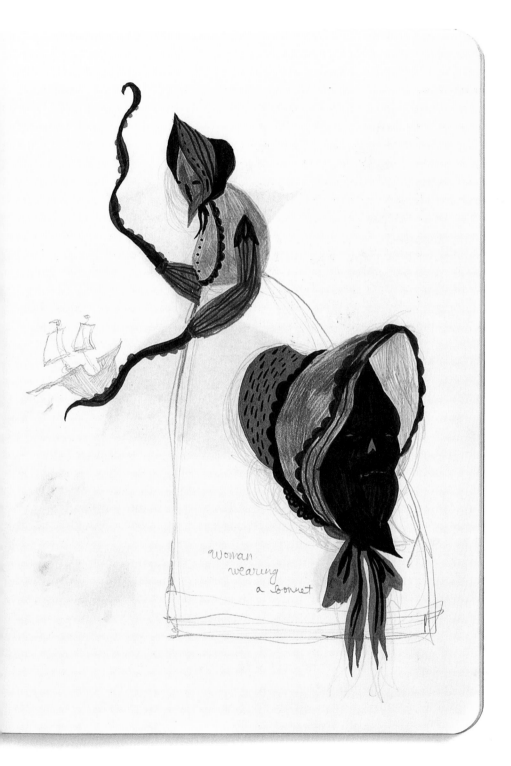

Woman
wearing
a Bonnet

That's hilarious. I sometimes wonder if people picture me as totally Goth and morbid … or better yet, as an actual practitioner of witchcraft. People might be surprised when they meet me after knowing my work, but they never tell me. It is pretty interesting how some artists represent their work in their persona and some don't. For me, these things are my personal interests, not my identity.

I think if anything, people are surprised to see my work after knowing me for a little while. I will try to describe my work to folks when they ask, but I never do a good job. So when they see it, they are like, "Oh! that's what you meant."

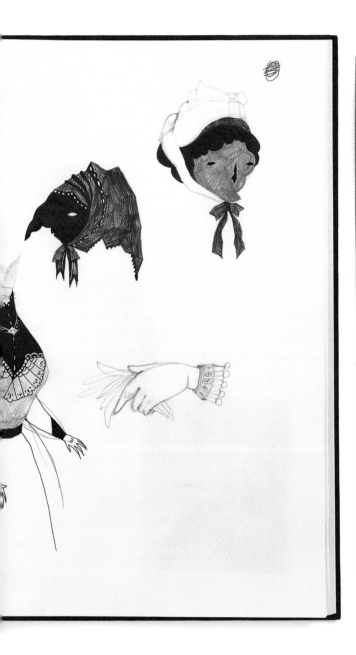

It's totally an escapist thing. Ever since I was a kid, I have wanted to get away from reality … only because the magical worlds of the books I read or the movies I saw seemed so much more exciting than my own. I totally blame all those amazing kids' movies from the '80s. *The Neverending Story, The Dark Crystal, Labyrinth, The Last Unicorn,* and *The Secret of NIMH* were true magic to me, and I now try to recapture that feeling of escape with my work.

It's also in my family. My grandfather on my mother's side was a paleontologist and an artist. He made fossil remains of mythical creatures out of rock and cast metals, while his wife, my step-grandmother, taught me about witches and spirit animals. Their house was full of magical books and treasures. We visited once a year, and it was like going to another world. If that had been my everyday, it might not have captured my imagination so thoroughly.

As an adult, though, I became interested in the way folktales differed throughout the world but retained similar themes and story lines. I am also interested in the submissive and dominant roles that females play in folklore and the dualities of characters like the witch or fair maiden. That's probably why all of my characters are female. It's a way of filtering my own feminist ideas through something magical and familiar.

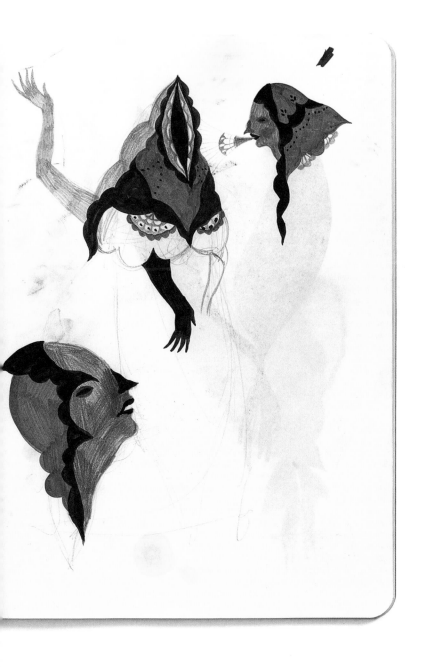

It all began with a love of doilies and lace. I used to crochet before I developed issues with my hand, so I would just bring the patterns I used in my crocheting to my work. I still love the lace, but the detailing is a great excuse to explore all types of decorative elements from women's costume history. For example, I was using a lot of structural elements of Elizabethan dress in my last body of work, and these days I am looking more at Victorian dresses and hats.

MEG HUNT

Phoenix, Arizona
www.meghunt.com

Meg Hunt is an illustrator
fascinated with life, nature,
animals, cities, and all the
details that make up this big
world of ours. She loves screen
printing, crazy patterns, retro
style, her microscopic canine
chum, cooking, animation,
character design, traveling,
autumn, collaboration, and
much more. Her clients have
included *Scholastic,* Cartoon
Network, *Jamie Magazine*,
Oxford University Press, and
Nickelodeon Magazine.

WHAT ARE THE MAIN FUNCTIONS OF YOUR SKETCHBOOKS?

Sketching is a chance to rough
out ideas, get a little ugly
without worry, practice little
figments of my imagination,
learn some ideas, and make
some notes. I don't document
life in sketchbooks much, but
I rather document ideas and
dreams in them.

I NOTICED THE RED AND BLUE PENCIL UNDERNEATH YOUR INK. WHY DO YOU USE THAT?

The red and blue pencil is for two reasons: one, sketching in colored pencil is less smudgy, and as a left-handed artist I find it easier to work with than graphite. Secondly, it's very light, and I can be a little rough with the drawing without having to worry about it needing to be erased once I need to scan the finished ink work—in Photoshop I can adjust the lines and lose the colored pencil work easily.

YOU STARTED A UNIQUE PROJECT CALLED, *PICTURE BOOK REPORT*. I RECOGNIZE SOME OF THE SKETCHES IN YOUR SKETCHBOOK FROM THAT PROJECT. CAN YOU TELL ME WHAT THE PROJECT IS ABOUT?

Picture Book Report is a project where fifteen talented illustrators have chosen a favorite book and serialize it in scenes every month. It's a project that revisits the love of books with pictures, which is not so common a practice for adults to read nowadays. But I remember growing up with so many great illustrated books and wanted to recapture that joy of words and pictures.

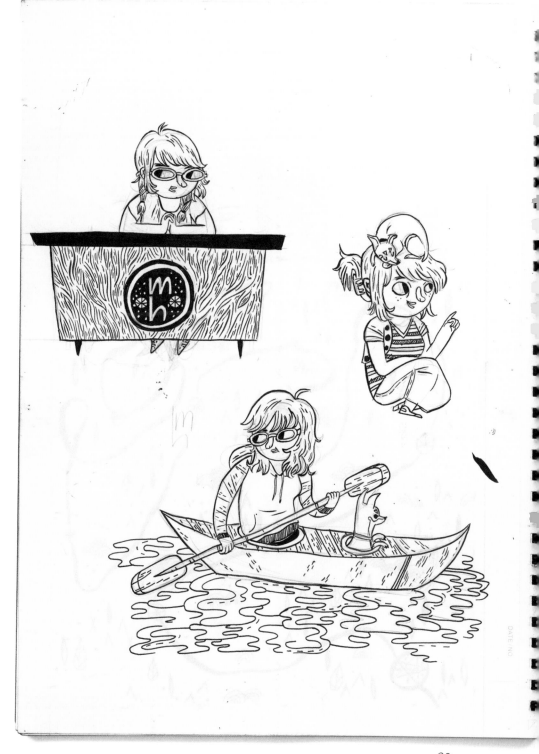

83

WHY DID YOU CHOOSE *ALICE IN WONDERLAND* FOR YOUR PROJECT? AND WHAT HAS IT BEEN LIKE DEVELOPING CHARACTERS FOR SUCH A POPULAR STORY?

Alice in Wonderland has always been a favorite story of mine; I think I've tried to draw the world of Wonderland at least two or three times before (with shameful results!) and always remembered enjoying the movie. Another side benefit of the project is that it was a favorite story of my late father, and losing him (at the start of 2010) informed the aesthetic of Wonderland in a way I never would have expected. I've adored working on the project. Of course, it's tricky breathing new life into characters that are so distinctive, but I think I've done a good job making her my own. Alice and her friends enchant me daily. If I had my way, I would publish a copy of the book with the illustrations or shake things up and animate Wonderland.

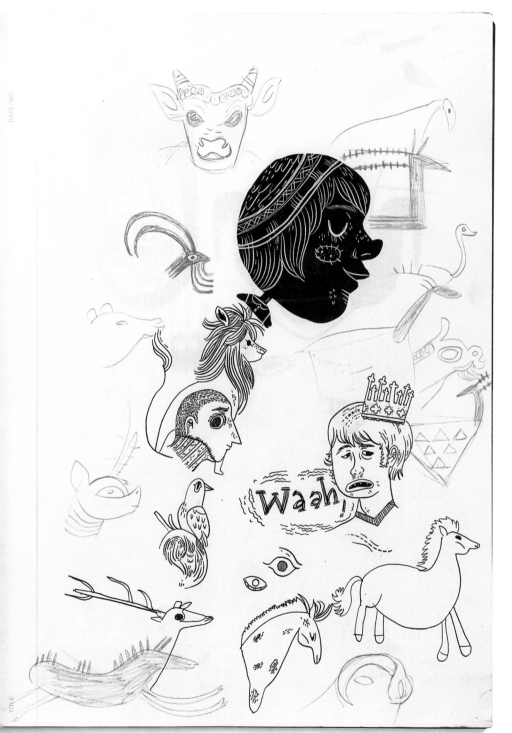

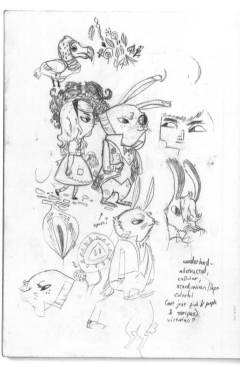

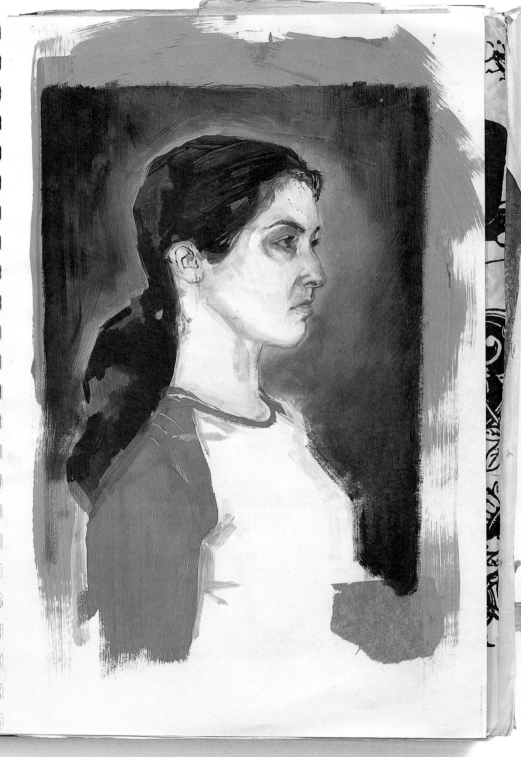

KAREN KLASSEN

Calgary, Canada
www.karenklassen.com

Karen Klassen's illustrations have been used in a wide range of applications from advertising campaigns and magazines to beer cans and snowboards. She works with a variety of mediums, including screen printing, watercolor, acrylic, and oils. Her work focuses primarily on portraits and people, finding an endless supply of inspiration from the figure. Her illustrations have won awards from Society of Illustrators LA, *Communication Arts, American Illustration,* and AR100 to name a few. She occasionally teaches at the Alberta College of Art and Design and has clients all over Canada, the United States, and Europe.

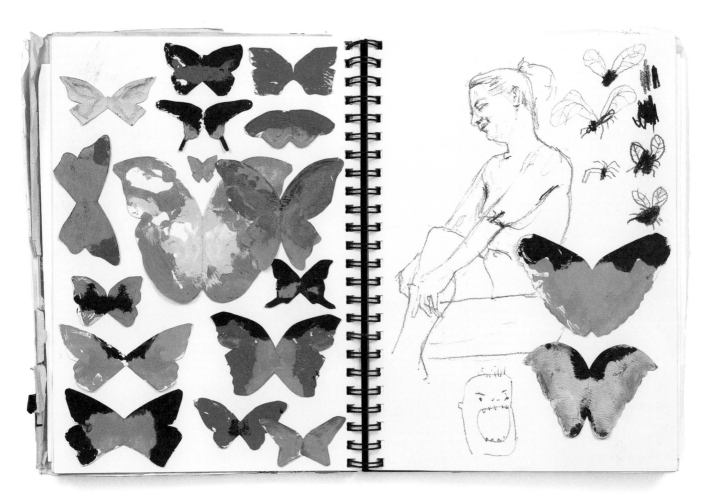

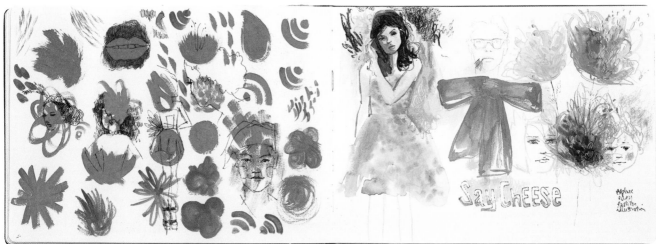

Say Cheese

87

DO PEOPLE EVER LOOK AT YOUR SKETCHBOOK? HOW PRIVATE IS IT?

Occasionally friends will look at it. I don't mind some people looking, but because of the notes I write in there (usually about process, goals, ideas, reflection, etc), I don't know that I would be comfortable sharing with many people, like having it on display somewhere. I guess it's a tiny bit private.

HOW DOES IT FEEL TO LOOK AT OLD SKETCHBOOKS?

On the one hand, I cringe a little because the work can be on the crappy side. On the other hand, there's a sense of relief that I'm actually improving my craft and not staying in the same place! Sometimes, I'll go back and read my notes in old books, trying to mine them for concepts or ideas that I've forgotten about or to use them as a jump off point for new work.

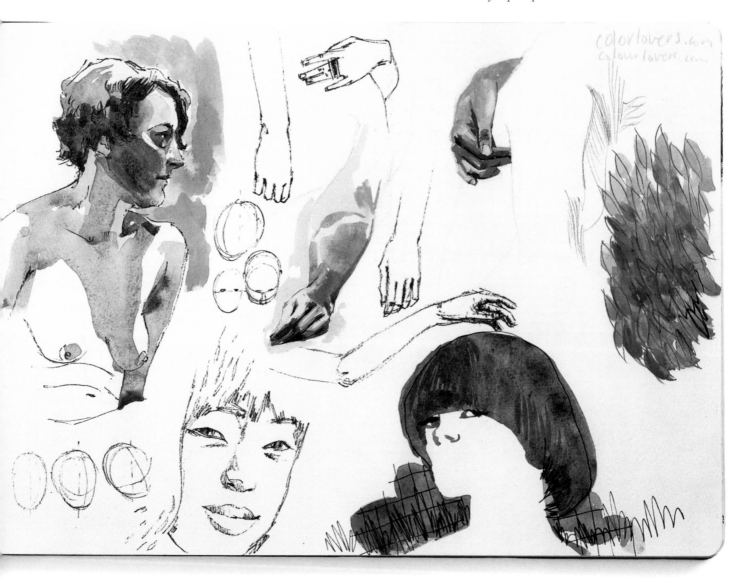

WHAT MEDIUMS DO YOU WORK IN? HOW DO THEY DIFFER FROM YOUR OTHER NON-SKETCHBOOK WORK?

I will work the same mediums in my sketchbook as I do in my non sketchbook work: oil, acrylic, screen printing, watercolors, gouache, collage, sewing … it doesn't change just because I'm doing a client job or working in my sketchbook. In fact, I usually test mediums in my sketchbook first, and then they may eventually work their way into my client work.

WHEN DID YOU GET YOUR FIRST SKETCHBOOK?

I was young. My parents were really supportive and provided me with many art supplies—maybe ten years old?

HOW MANY SKETCHBOOKS DO YOU HAVE? WHERE DO YOU KEEP THEM?

I have between twenty and thirty books. Some are put away so I lose count. I keep the majority of them in my studio; some in the bookshelf, some in boxes.

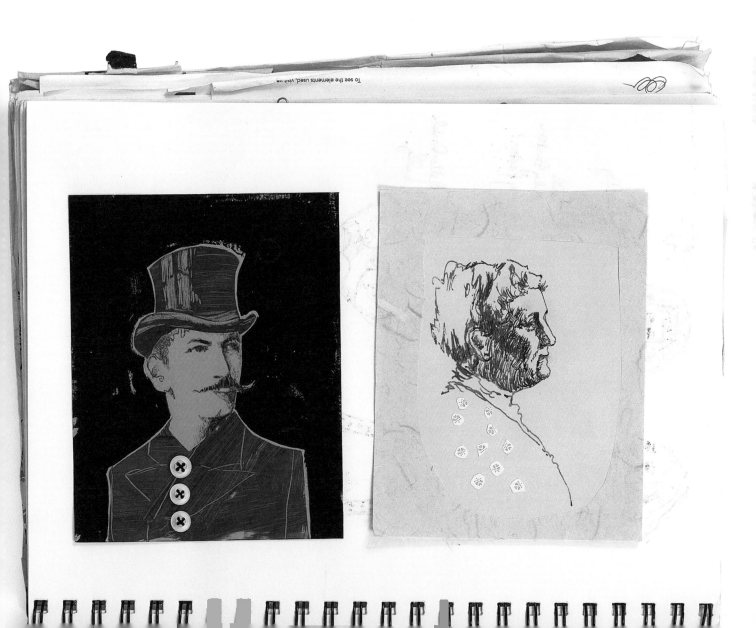

CHAD KOURI

Chicago, Illinois
www.longliveanalog.com

Chad Kouri is a living, breathing, mobile human being in the great city of Chicago. When not working on commissioned illustration and design work, hand-lettering poorly spelled phrases, art directing *Proximity* magazine, rockin' out on found object installations/collage pieces, or blog jammin', space touring, curating, and high-fiving with The Post Family crew, he hibernates like the great grizzly.

WHAT ARE THE MAIN FUNCTIONS OF YOUR SKETCHBOOKS?

It's a combination of reference material, memorabilia from places I go, and explorations in type and collage. A lot of my type illustrations that I use for commissioned work come from scans right out of the sketchbook. I would say 99 percent of my ideas start in my sketchbooks. They are priceless to me. Sometimes notes and to-do lists get in there, but I try to keep it pretty visual. Sometimes I'll go back and add things on top of pages with old notes that I don't need anymore. That's always a fun experiment.

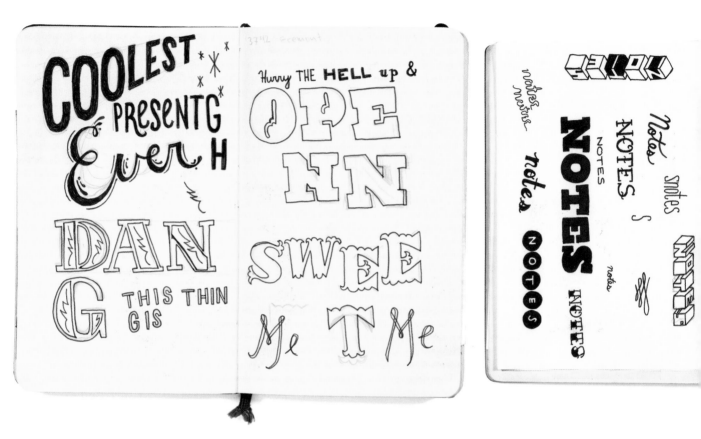

WHAT MEDIUMS DO YOU WORK IN? HOW DO THEY DIFFER FROM YOUR REGULAR WORK?

I use anything and everything in my sketchbook: markers and pencils to coffee and wine. Most of that stuff finds its way into my final work. The sketchbook is where I get a lot of the happy accidents that I enjoy so much. Oh, those happy accidents. If I ever start an idea in my sketchbook and move on to larger paper or tracing paper (I use so much tracing paper for type), I usually fold it down and tape it in the sketchbook or make a pocket so all my material from one project stays together.

ARE THERE CERTAIN BOOKS OR LETTERING EPHEMERA YOU USE FOR INSPIRATION?

I really like old wood type specimen books. They are the best. I have a pretty large collection of old typography books—everything from sign painting how-tos to embroidery and cross-stitching books that have type in them and also old packaging and print material. While sourcing images for my collage work, I find a lot of old custom lettering in ads and things like that. In the '60s and '70s, there was a lot more custom type in print because typefaces were not as readily available and easily reproduced as they are today.

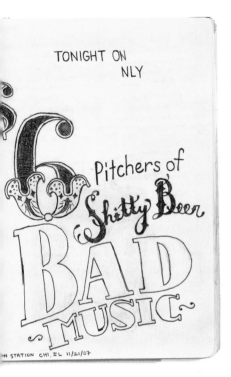

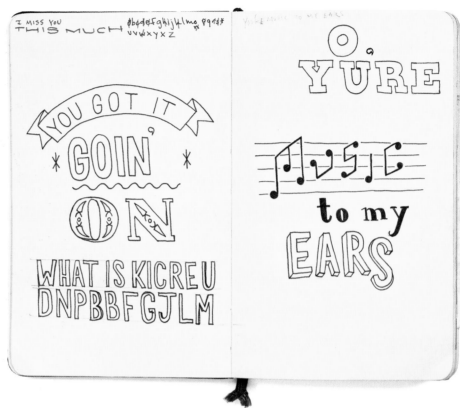

HOW DID YOU GET INTERESTED IN CREATING LETTERING?

I'm pretty sure it came from a subconscious interest when I was really young. I was diagnosed with dyslexia when I was in first or second grade. I think that gave me a huge interest in letters early on because when I was learning to read, I was looking at pieces of letters and individual letters into single words rather than looking at words into sentences into paragraphs. Some of my tutoring included drawing words in sand and other experiments like that to see which method was the best for my mind to retain the information. Jump to seventh grade, my handwriting was really bad and I was just beginning to be interested in graffiti but was way too much of a goody-goody to vandalize anything, so I decided to reteach myself how to write. I have notebooks at my parents' house full of just one letter over and over again. My handwriting has evolved since, but I still use the double-story lowercase *a* that I learned back then in my handwriting today. So my subconscious interest slowly led me from graffiti to digital fonts to custom type for logomarks and branding, then to hand-drawn type inspired by sign painting and tattoo lettering, which evolved into interest in decorative and Tuscan lettering, and then on to wood type and letterpress processes and other printmaking.

MATT LEINES

Philadelphia, Pennsylvania
www.mattleines.com

Matt Leines's finely detailed paintings and drawings are an amalgam of memories, filtered influences from the long and varied histories of art and culture, and life's obsessions. The emphatically meticulous lines speak to a primitive, yet undeniably modern aesthetic. His work has been showcased in exhibitions and collections across the globe. His first monograph, *You Are Forgiven*, was published by Free News Projects in 2008. Matt lives and works in Philadelphia.

YOU HAVE A LOT OF COLLECTIONS. WHAT ARE THEY?

Yeah, I have too many. I'm trying to find good homes for some of them. The ones I care about are 'zines and books and art for obvious reasons. My biggest collection is my wrestling toys, which still gets added to sometimes even though it's already way too big. I guess I collect those because I've always loved wrestling. But some are pretty dumb. I just gave away my religious tracts, and if you know anyone who wants about eighty TV remotes, let me know. I think the main reason to collect things is some sort of control complex.

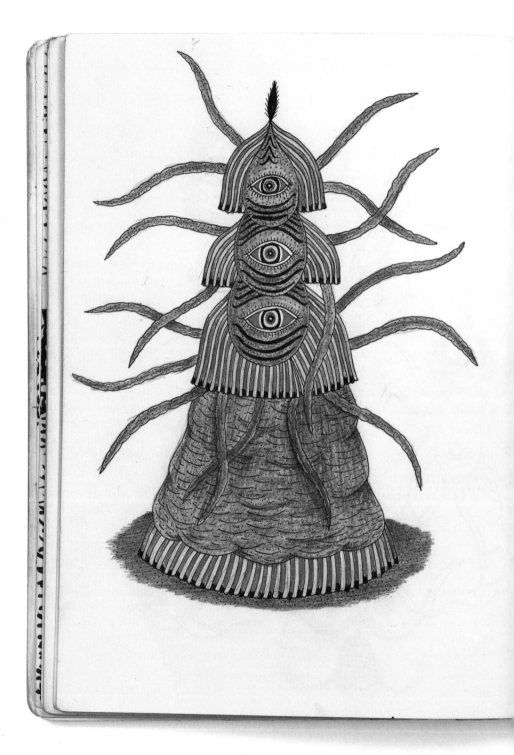

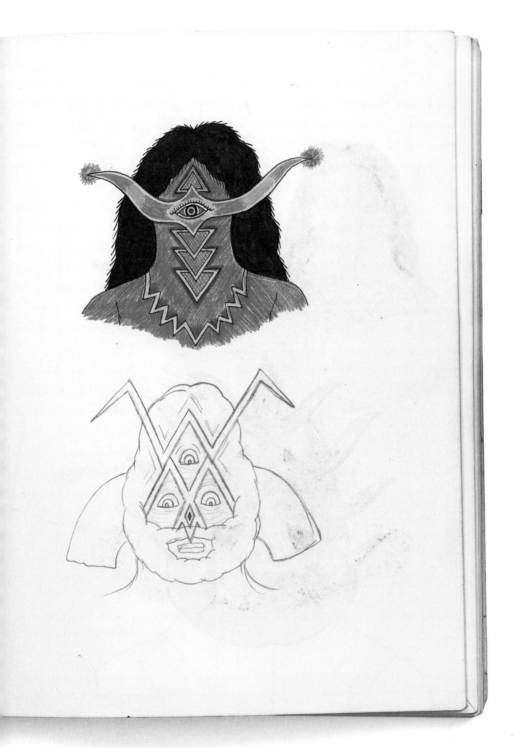

HOW MUCH PLANNING GOES INTO YOUR FINISHED PIECES? DO YOU DO A LOT OF SKETCHING BEFORE YOU START A PAINTING?

Yeah, a lot of sketching goes into a finished piece, sometimes maybe too much. Lately I've been finding I like it better when I can change things around once a painting gets pretty far along. Basically, I'll take a rough idea and decide on a way to turn that into a finished piece, then develop each part as more evolved sketches, which become the final piece.

WHAT DID THE DRAWINGS IN YOUR HIGH SCHOOL SKETCHBOOK LOOK LIKE?

Before college I never worked in sketchbooks. I remember getting boxes of old dot matrix printer paper with the tabs you'd have to rip off, and I'd draw on that. A lot of what I'd draw back then was pictures from baseball cards and wrestling magazines or characters from video games. If I made a mistake, I'd scrap that sheet and start over. I remember thinking if it wasn't perfect it wasn't worth saving. In college, when I was consciously trying to develop a way of drawing, I realized that I could learn things from sketches that weren't quite right, and even now I'm figuring things out from some of those old unfinished sketches.

95

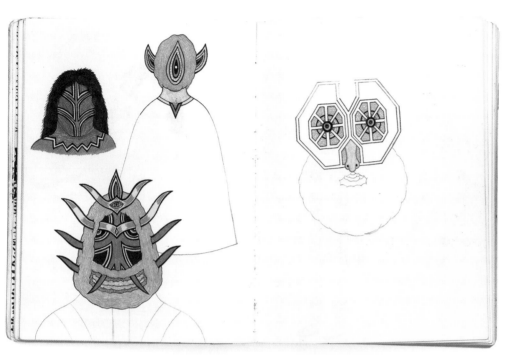

YOU'VE RECENTLY STARTED SHIFTING YOUR STYLE MORE BY LOOSENING YOUR DRAWINGS A LITTLE BIT. WHY DID YOU DECIDE TO START WORKING IN THIS WAY?

For a long time I really strived to make my paint application as smooth and flat as possible. After a while, I got fed up with that because it never got as smooth as I wanted. I figured I'd try to go the opposite direction instead, and it was a real struggle. In college, I worked really loosely, before I started making things in the style people would currently recognize. I think it's still developing, but so far I've been really excited by the results. The looseness is creating much more depth in my work, which should have been obvious, and then the line work is still mostly tight, which tidies everything up.

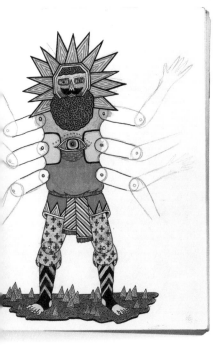

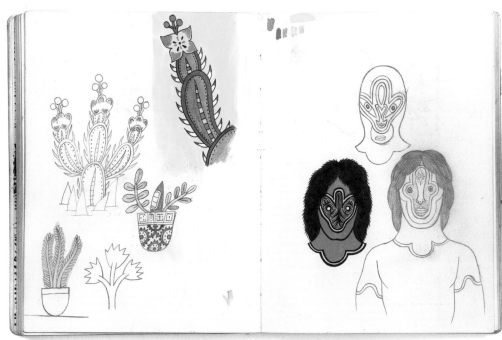

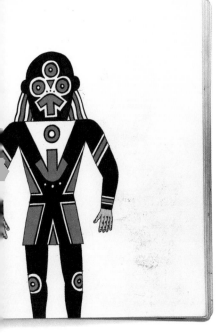

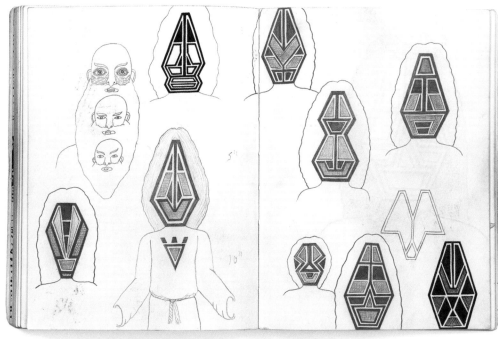

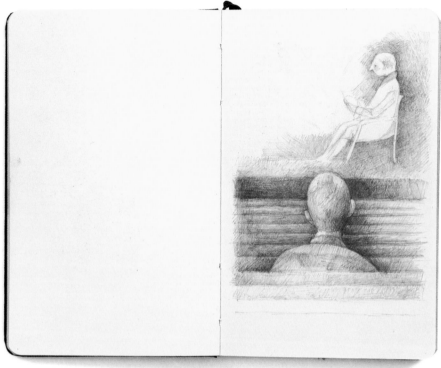

RENATA LIWSKA

Calgary, Canada
www.renataliwska.com

Renata Liwska does her sketchbook drawing from Calgary, Canada. She draws in her sketchbook daily, both for fun and for fun children's books, such as the *New York Times* best seller, *The Quiet Book,* written by Deborah Underwood and published by Houghton Mifflin Harcourt. She has two books coming out in spring 2011, *Red Wagon,* which she wrote and illustrated for Philomel Books, and *The Loud Book,* a sequel to *The Quiet Book.* Her previous picture books include *Little Panda,* which she wrote and illustrated, and *Nikolai, the Only Bear,* by Barbara Joosse.

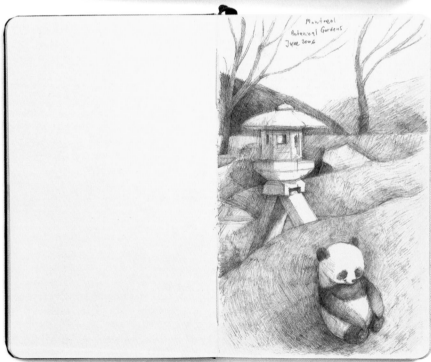

Montreal
Botanical Gardens
June 2006

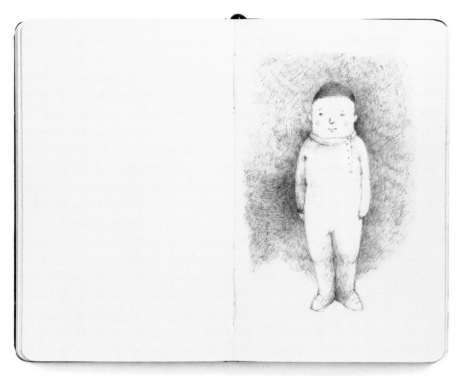

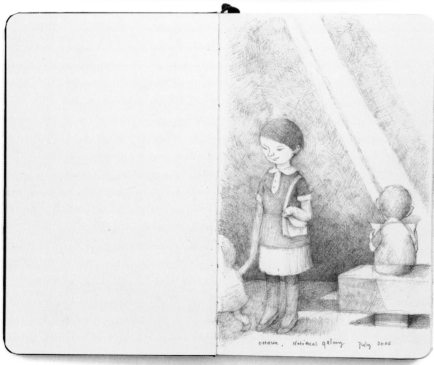

ottawa, National galery July 2006

WHAT ARE THE MAIN FUNCTIONS OF YOUR SKETCHBOOKS?

Work and fun. But since my work is quite a lot of fun, I guess it would be mostly fun. It can also be very therapeutic and relaxing if I can get myself to not take drawing too seriously.

HOW OFTEN DO YOUR SKETCHBOOK DRAWINGS GET USED IN PROFESSIONAL WORK LIKE YOUR CHILDREN'S BOOKS?

Almost all of my illustrations are drawn in my sketchbooks. I scan the drawings and then color them in Photoshop. When working on a children's book, I draw some thumbnails outside of my sketchbook. But even with these, I create a dummy out of folded and stapled sheets of paper that are put together like a book.

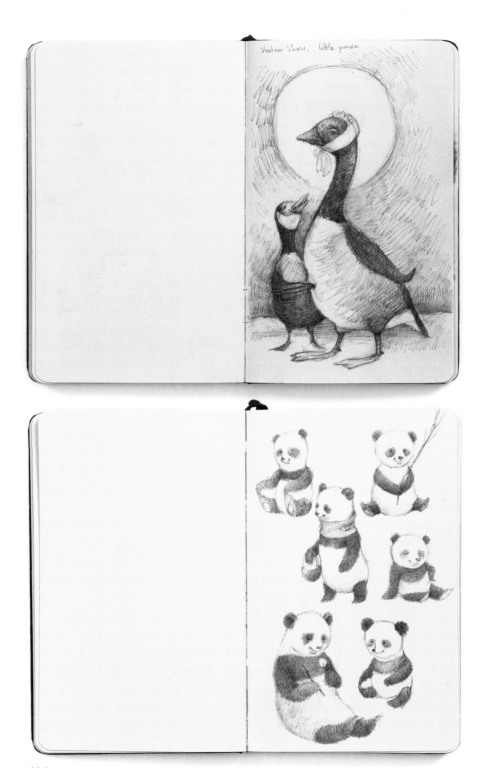

Before I started doing children's books, I showed my portfolio to an editor who was a guest speaker at a local children's book illustration conference. The editor, Allyn Johnston, mentioned that my characters often seemed very sad, and I should try to show more variety and draw them happier. At about the same time, I sent out some promotional mailers to book publishers. I included a postage-paid comment card along with the promotional material. Quite a few editors and art directors returned the comment cards, and I received similar feedback about my characters being a bit too melancholy. So now I try to make sure my characters are having fun, when they can.

Also, at that time I was mostly drawing children. But I had done a series of sketches featuring a goose (he was having fun). These drawings are what attracted the attention of art director Semadar Megged at Philomel Books, which lead to my first book, *Nikolai, the Only Bear,* written by Barbara Joosse. After that, I started drawing more animals, and now I rarely drawing anything else.

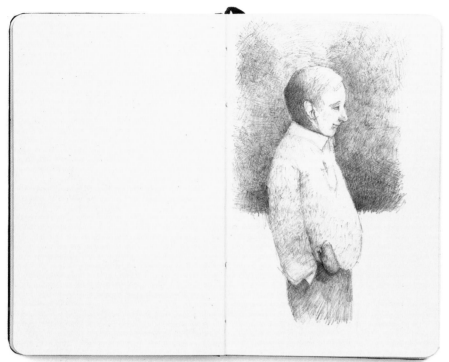

HOW DOES YOUR CHILDHOOD GROWING UP IN WARSAW INFLUENCE YOUR WORK?

When I illustrate my own words or someone else's, I always use experiences from childhood as my inspiration. Often the animals are doing things I did when I was growing up. It also affects my work in other ways, such as my color palette. The books I grew up with in Poland were never brightly colored; they always seemed to be printed with muted colors. But I loved them. I prefer a muted color palette in my own work, which is a challenge because people often like bright colors for children's books.

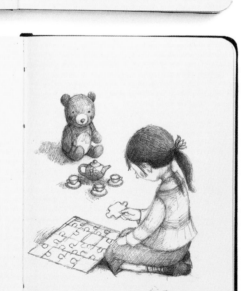

R.L.

MIKE LOWERY

Atlanta, Georgia
www.argyleacademy.com

Mike Lowery is a freelance illustrator who lives in a tiny cottage surrounded by trees where he mostly just makes art. His work has been seen in galleries and publications internationally, and he is a professor of illustration at the Savannah College of Art and Design in Atlanta. His daughter, Allister, loves it when he draws faces on their bananas.

MANY OF YOUR COMICS ARE AUTOBIOGRAPHICAL. HAVE ANY ISSUES COME UP WITH YOUR FRIENDS OR FAMILY WITH HOW YOU'VE PORTRAYED THEM OR WHAT YOU HAVE SHARED IN YOUR WORK?

Actually, my comics are usually only loosely based on real events, though a few issues have come up: 1) I've had friends ask why they don't make it into the comics/journal entries and 2) I do tend to name characters after friends of mine, and recently two of the friends who have been presented as a couple in the comics separated. I'm still not sure really what this means for the characters, but it could be a little hurtful or awkward for me to continue them with the same names. I'm not sure.

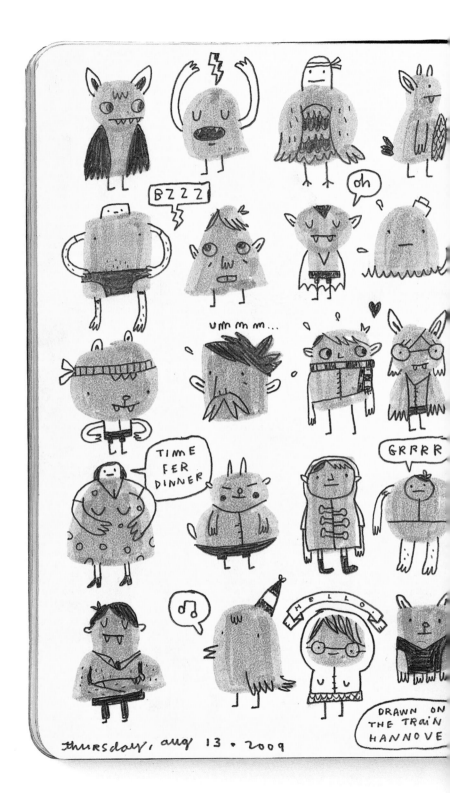

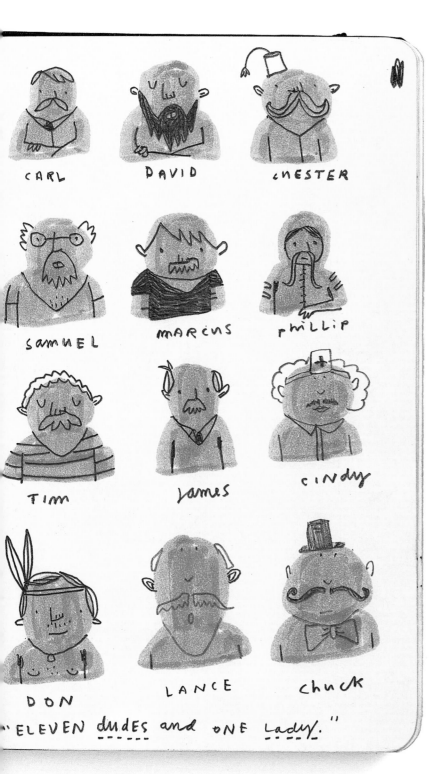

CARL

DAVID

CHESTER

SAMUEL

MARCUS

PHILLIP

TIM

JAMES

CINDY

DON

LANCE

chuck

"ELEVEN dudes and oNE Lady."

WHEN DO YOU USUALLY WORK IN YOUR SKETCHBOOK? WHAT TIME OF DAY AND WHERE?

I work on the sketchbooks whenever it comes to my mind. Meaning: I don't have a system for how I journal. I usually just draw with a mechanical pencil, and I try and keep one with me so that if I'm sitting having coffee, or riding the train, or whatever, I can just draw something or make notes. My main goal of keeping a sketchbook is to give me a reason to draw something every day, so I try not to set up little things to keep me from doing that, like needing the conditions to be perfect before I allow myself to draw. I've seen a lot of artists do this, and I do it myself sometimes, and it's an easy way to stay locked up and not get art done.

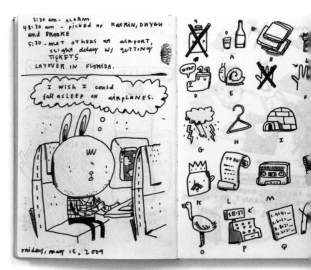

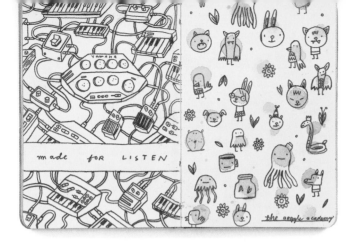

IF YOU COULD PEEK INSIDE ANYONE'S SKETCHBOOK DEAD OR ALIVE, WHOSE WOULD IT BE?

Easy. Richard Scarry. I can't imagine any other illustrator as creative and as ridiculously prolific as that guy, and it would be great to see what his process was like. Though, with the insane number of books that he put out (and seeing as how they were usually crammed with little characters), I could imagine his sketchbooks being easily neglected. I read that he published more than 300 books … how could he possibly have time to draw something off the target of finishing a book?

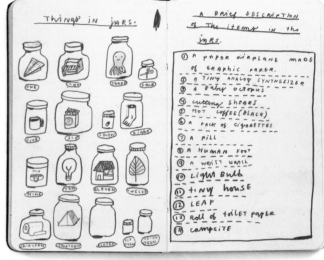

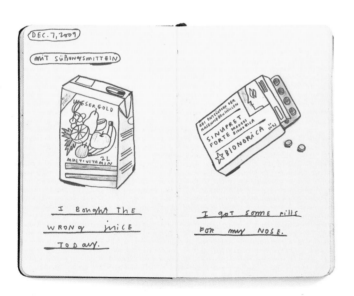

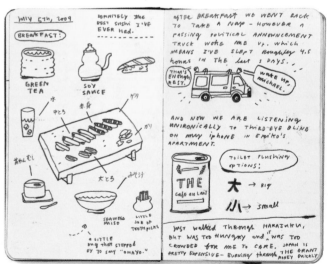

WHAT ARE SOME OF THE PLACES YOUR SKETCHBOOK HAS TRAVELED WITH YOU?

Since I take my journals with me wherever I travel, they end up seeing a lot places. One small Moleskine will usually last three months or so, so they usually end up with a few cities or countries per book. I actually keep a little log at the front of the books to record where all they've been, and I like to record interesting things about my trip during the day. Over the past few years, I've taken sketchbooks across North America, China, all over Japan, several cities in Germany, France, the Netherlands, the Dominican Republic, Italy, the Caribbean, Scandinavia, and the Czech Republic. Luckily, being a teacher and freelance illustrator means getting to take a little more vacation time than some other jobs I've had, so I try and use my time off to get out of town.

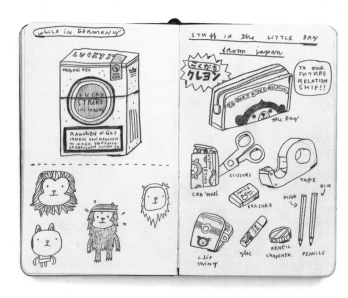

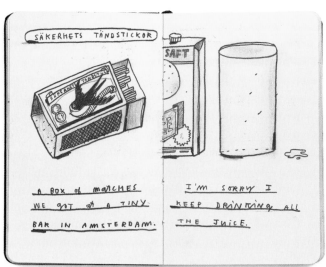

ALEX LUKAS

Philadelphia, Pennsylvania
www.alexlukas.com

Alex Lukas was born in Boston, Massachusetts, in 1981 and raised in nearby Cambridge. With a wide range of artistic influences, Lukas creates both highly detailed drawings and intricate Xeroxed 'zines, comics, and booklets. Lukas' imprint, Cantab Publishing, has released over 30 small books and 'zines

since it's inception in 2001. His drawings have recently been exhibited in New York, Boston, Philadelphia, Los Angeles, San Francisco, London, and Copenhagen, as well as in the pages of *Swindle Quarterly*, *Proximity* magazine, *The San Francisco Chronicle*, *The Village Voice*, *Philadelphia Weekly*, *Dwell* magazine, and the *New York Times Book Review*. Lukas is a graduate of the Rhode Island School of Design and now lives in Philadelphia, where he is a member of the artist collective, Space 1026.

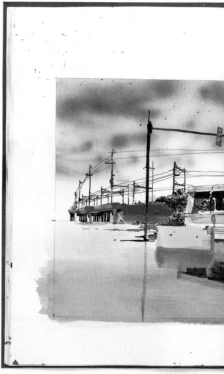

HOW MUCH OF YOUR SKETCHBOOK WORK IS PREPARATION FOR BIGGER ARTWORK?

The sketches often turn into the beginnings of larger works, but the compositions generally change in the sizing-up process. For years I didn't make any sketches, I would just dive into drawings blind, but that resulted in a lot of false starts (and wasted paper). For the past year or so, I have been consciously trying to make sketches and then actually pay attention to them when working on the final drawing. I use the sketchbook as a palette for mixing paint and figuring out colors. Generally, the book is right next to me or actually on top of the piece while I'm drawing.

HOW DO YOU PICK YOUR PALETTES?

I generally just mush things around and test out colors until I get what I like. Most of the drawings are some combination of acrylic paint, watercolor, gouache, ink, and silkscreen all mixed together, and I use the sketchbook as a test surface. When I get a color or texture I really enjoy, I try to make a note of what I mixed to come up with it. Then I can come back to the book later and try to match a color, especially if it is something I haven't used in a while.

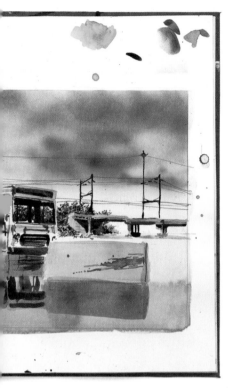

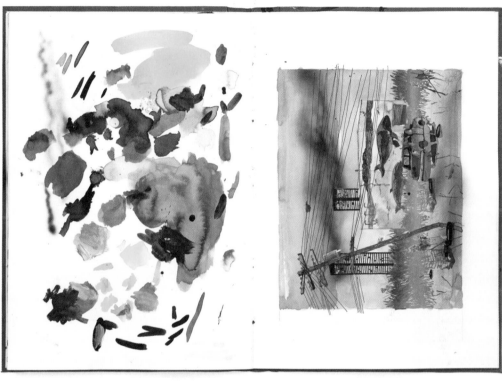

ARE YOU MORE PRODUCTIVE WITH YOUR WORK WHEN YOU ARE ALSO WORKING IN A SKETCHBOOK?

Not really. If anything, I use my sketchbook when I am in a rut and not being productive.

DO PEOPLE EVER LOOK AT YOUR SKETCHBOOK? HOW PRIVATE IS IT?

It isn't intentionally private, but I don't usually show it to people unless I have an idea that I want some feedback on. Obviously, a lot of the sketches go nowhere, and part of the process of sketching for me is getting out those bad ideas. So when I do show people the sketchbooks, I try to be selective. There is a lot of me hovering over the person's shoulder, saying, "Yeah, that didn't really work … um, skip that page … okay, this one I like."

GRADY MCFERRIN

Brooklyn, New York
www.gmillustration.com

Grady McFerrin is an artist who lives and works in Brooklyn, New York. He has small teeth. He loves anchovies. He once found himself wearing flip-flops in the middle of a late winter snowfall. He used to be a substitute teacher in Oakland, California, and at an all-time low point was pelted with thumbtacks by a group of derelict students. He loves coconut ice cream, especially the kind that you eat right out of the shell with a little wooden spoon. He hates the way hotels tuck in their sheets tightly under the mattress. He usually has to pull them out so he can fall asleep. He shares a studio with four illustrators in an old pencil factory that produced the first eraser-capped pencil. He has designed several posters for the historic Fillmore Theater in San Francisco, and he has a line of stationery products published by Chronicle Books. Other clients include the *New York Times, The New Yorker,* Bonny Doon Vineyard, Random House, Simon & Schuster, and Asthmatic Kitty Records.

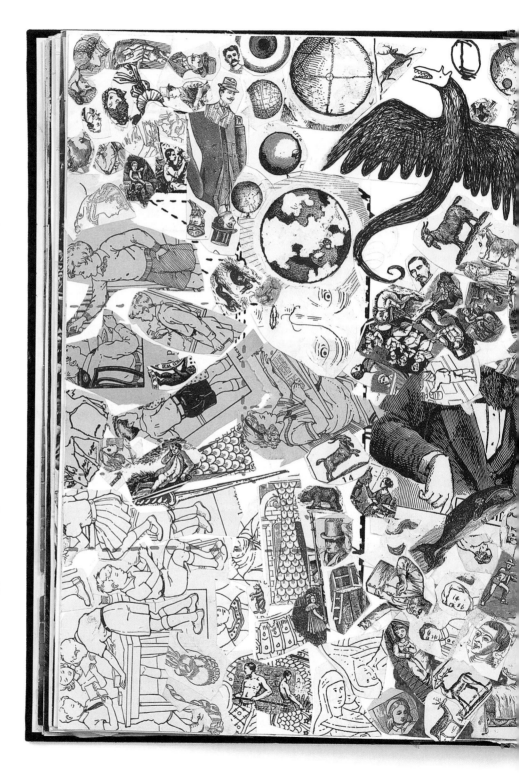

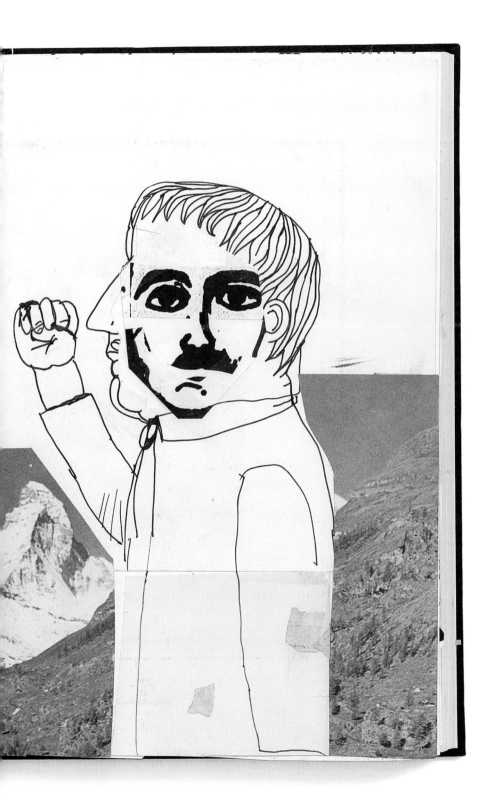

I think our culture is generally obsessed with the "new." We are constantly being told that new stuff will make us more comfortable; new things will make us happy. I don't feel like that's true at all. I love all my old books, music, furniture, and art supplies. I try to submerse myself in that world, so that it can somehow come through in my work. I never go straight to my sketchbook without looking through old books or magazines for imagery that inspires me.

THERE ARE SO MANY LAYERS TO SOME OF YOUR SKETCHES. FOR EXAMPLE, YOU MIGHT USE PAPER THAT'S BEEN PRINTED ON ALREADY, THEN ADD PAINT FOR COLOR, AND THEN ADD INK LINE WORK ON TOP. IS THERE A PROCESS YOU FOLLOW, OR IS IT MORE INSTINCTUAL?

I think the layering is mostly a way to cover up my mistakes, so I would say it's definitely instinctual. The best part about a sketchbook is that you can keep editing a page until you're happy with it. The only hard part is deciding what medium will best edit the previous layer. Paint? Tape? Wite-Out? Xerox transfer?

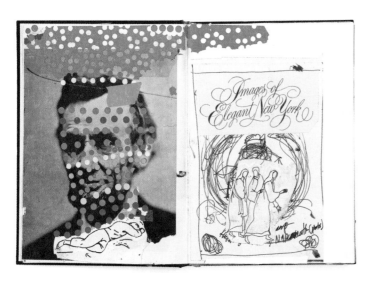

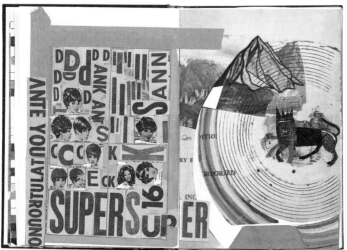

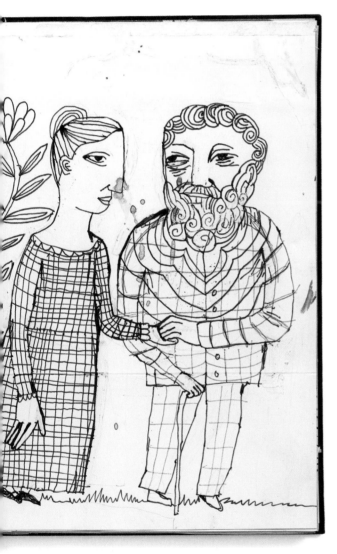

YOU STARTED OFF ON THE WEST COAST BUT NOW LIVE AND WORK IN BROOKLYN, NEW YORK. DO THINK YOUR WORK CHANGED AS A RESULT OF MOVING EAST? HOW INFLUENTIAL ARE YOUR SURROUNDINGS?

You can't create art in a vacuum. This is especially true in New York. Artistic influences are all around you whether you like it or not. If you live in Brooklyn, you don't even have to try; you will be exposed to all kinds of fresh new talent. I never felt that kind of energy in San Francisco or L.A. Of course, the Web IS making everything accessible now. You can live in Alaska and read the same blogs I read, but there's something about the communities in New York that challenge you to become a better artist. I think my competitive nature drew me to New York so I could be around people that are smarter and more creative than I am. I believe some of that has definitely rubbed off on me. I hope I'm a better artist because of it. Also, New York has the American Folk Art Museum and the Cloisters, which are my two favorite places anywhere.

HAVE YOU NOTICED RECURRING THEMES IN YOUR SKETCHBOOKS?

Not really, but I'm sure any college art major could point out an abundance of recurring penises. Oh, I'm sure there are more than a few.

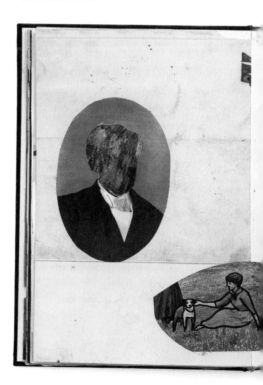

TED MCGRATH

Brooklyn, New York
www.tedmcgrath.com

Ted McGrath grew up in the woody suburbs of Philadelphia, Pennsylvania. He skipped town in 1998 to attend Pratt Institute and has inhabited various nooks and crannies in Brooklyn, New York, ever since. He currently enjoys making pictures and sounds with pretty much anything that comes to hand and staying up as late as possible. He is NOT the motivational outsourcing guru of the same name, though he shares that gentleman's enthusiasm for cool belt buckles.

HOW OFTEN DO YOU WORK IN YOUR SKETCHBOOK?

These days, at least once a week, although sometimes more, sometimes less, depending on what else is going on. I used to really make a point of spending some significant time on the book every day, but after a while I started to feel like the results of this regimen were getting predictable and a little stale.

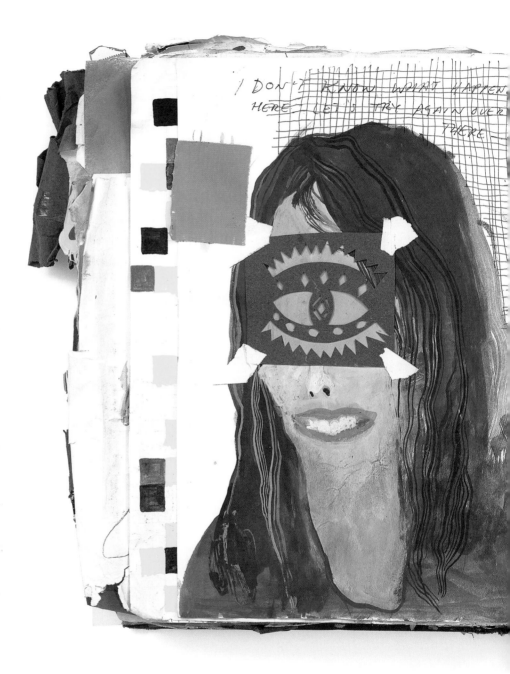

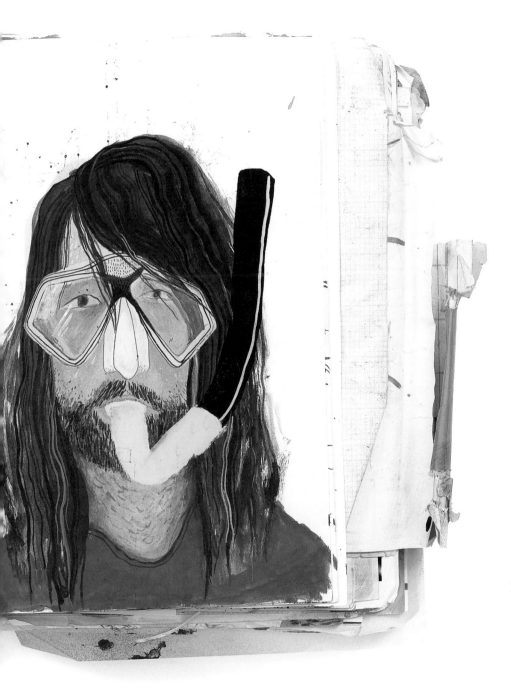

IS YOUR APARTMENT AS CHAOTIC AS THE INSIDE OF YOUR SKETCHBOOK?
Ha! Once upon a time, yes, but then my girlfriend moved in and I decided I liked owning a pair of pants or two that weren't covered in ink.

YOUR AESTHETIC SEEMS CONSISTENT BETWEEN YOUR SKETCHBOOKS AND YOUR PROFESSIONAL PROJECTS. IS IT SOMETHING YOU ARE WORKING TO MAINTAIN, OR DOES THIS CONSISTENCY COME NATURALLY TO YOU?
My sketchbooks definitely grew, in part out of a desire for more "self-authored" content and also as a bit of a lab for experimenting with materials, ideas, processes, etc. That said, I always look at them as part of my illustration portfolio and methods, so there's a bit of a two-way exchange of materials and ideas between the commissioned illustrations and the things I do on my own in my sketchbook. I definitely show pieces from my sketchbook in my portfolio and I've had them licensed from me on occasion, which is great, you know, getting paid for something sort of retroactively that you would've done anyway.

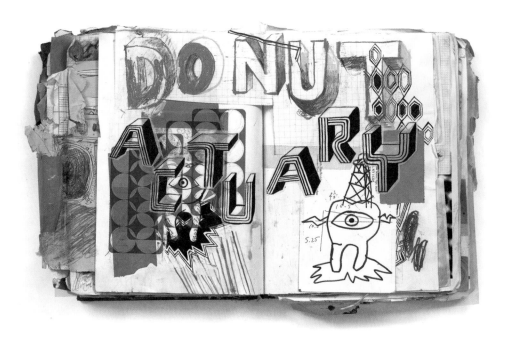

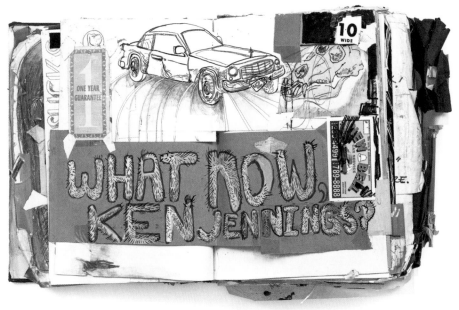

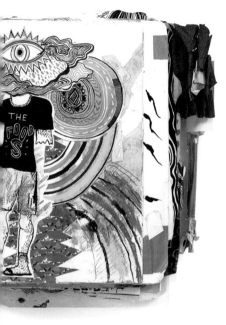

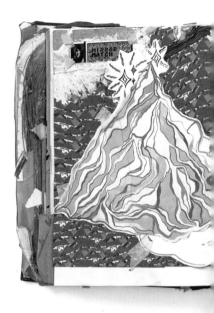

HOW MANY SKETCHBOOKS DO YOU HAVE? HOW LONG DOES IT TYPICALLY TAKE TO FILL ONE UP?

I'm usually working on at least two at a time, a little Moleskine-type thing that I carry around in my back pocket for doodling and sketching while I'm out and about and the "big" book. The little guys I can usually kill in a month or two, while the big ones take YEARS. I used to just carry around one of the big guys with me all the time, but as they grew more layered and denser in terms of the collage materials and paint, it just became too much of a hassle to have this precariously assembled, sometimes soggy falling-apart book in a messenger bag all the time. Once the larger books fell out of daily use, they really slowed down in terms of completion time, although I'm generally happier with the pieces from page to page, with less of an impulse for revisions.

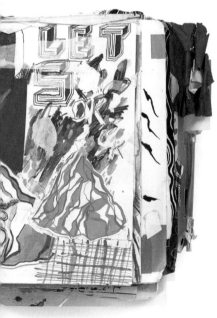

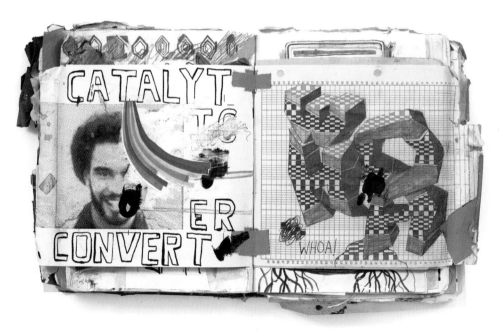

ANDY J. MILLER

Columbus, Indiana
www.komadesign.co.uk

Andy J. Miller is an illustrator/ graphic designer originally from Indiana. From 2005 to 2009, Andy lived and studied in the United Kingdom. Returning to Indiana, he now focuses his efforts on illustration and design for clients around the world. In August 2009, with the help of *The Yellow Bird Project*, Miller's book, *The Indie Rock Coloring Book,* was published internationally. Following the original concept Andy had created while in school, all the royalties for the book go to charities chosen by the bands. The first print run sold out within a month. Since graduation, Miller has worked with an array of clients, including Sony, *Yo Gabba Gabba,* Starburst, Converse, *NYLON* magazine, Smart Cars, Virgin Media, Barclays Bank, and more.

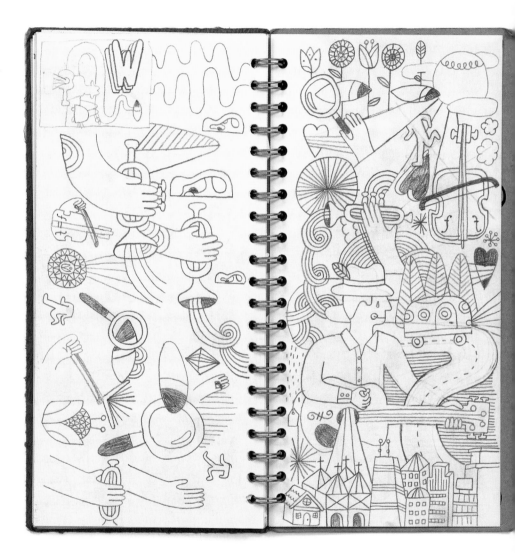

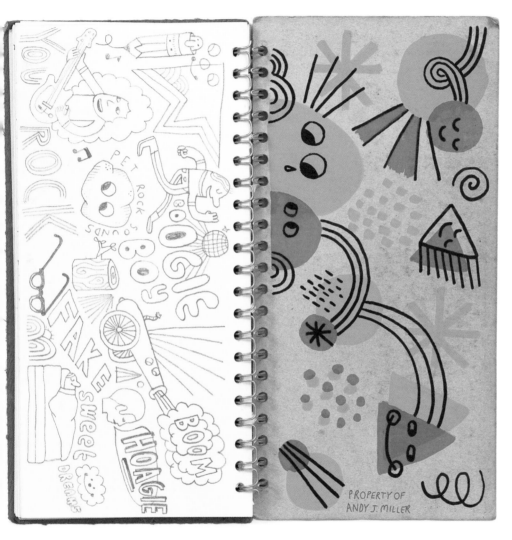

PROPERTY OF
ANDY J. MILLER

WHAT ARE THE MAIN FUNCTIONS OF YOUR SKETCHBOOKS?

Idea generation 100 percent. Whenever I have something new to work, I head straight to the sketchbook. For any given piece of work I sketch two to five pages in my sketchbook. I draw and draw and link images and feed off other images until I have a big stockpile of symbols and drawings to start picking and choosing from. I also take it to a lot of places to just doodle and draw things about what I am experiencing, thinking, and feeling. A lot of my personal work comes straight out of my sketchbook and gets slightly reinvented.

WHAT ARE THE RECURRING THEMES IN YOUR SKETCHBOOKS?

Humor, quality of lines, constantly trying to find similarities in shapes between figures; seeing how things match and connect; mashing up several symbols; developing textures; nonsense.

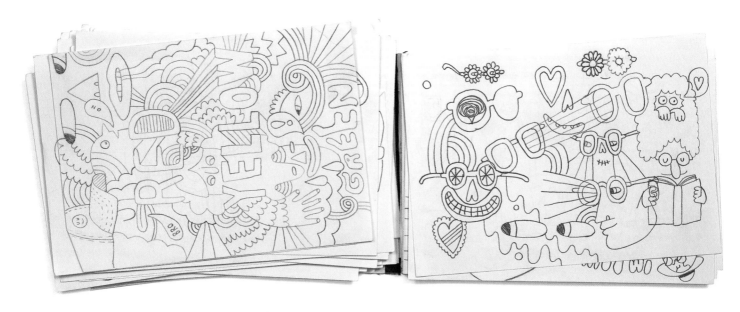

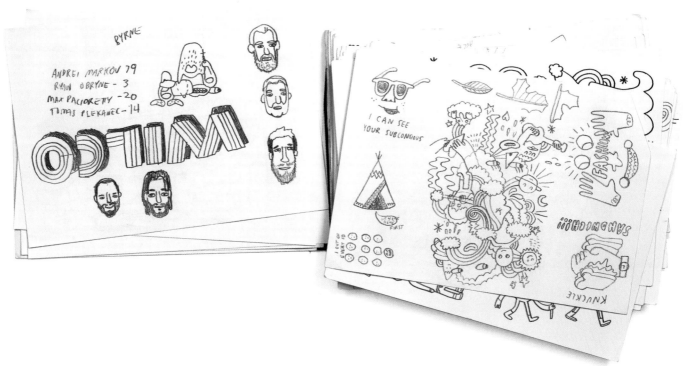

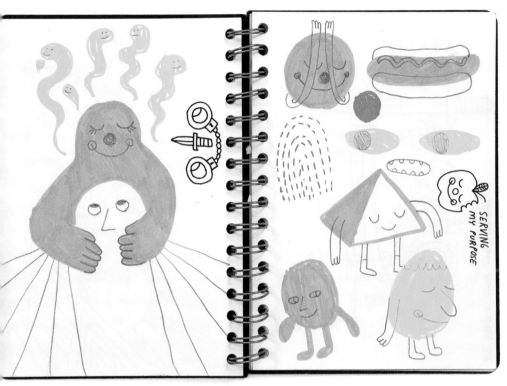

IS THERE A REASON YOU WORK MOSTLY IN PENCIL IN YOUR SKETCHBOOK? YOUR FINISHED WORK IS USUALLY VERY COLORFUL.

That's a great question. I think for me the sketchbook is always a starting block. Color always comes later in the finishing touches. I spend tons of time at the end working with color until it looks exactly as I want it, but my passion starts with the images. Also, I love to start with the idea, and the colors always reflect the idea, so they just naturally get left out of the first stage, which is the sketchbook.

WHO ARE SOME ARTISTS WHO INSPIRE YOU?

Ah, an age-old question. They are constantly changing; however, I am finding that I am indeed being more and more inspired by older work the older I become. I am very aware that Paul Rand is kind of a cop-out answer, but he truly is an inspiration to me. When I listen to the things he said and his approach, he really demystifies design and his approach has really helped me think more clearly. Some other classic inspirations are Jim Flora and Saul Bass. Some guys who have a great foundation in the industry and that really impress me with their consistency and high standards of craft are guys like Mario Hugo, Steven Harrington, Geoff McFetridge, and Genevieve Gauckler. Micah Lidberg, who I believe is fairly new to the scene, is blowing my mind. Some other fairly new guys that I am loving are Yehteh, Jon Boam, and Jean Jullien.

WILL MILLER

Chicago, Illinois
www.jwillmiller.com

Will Miller is a Chicago–based design creative who has been at Firebelly Design since 2007. His work has been featured in *Print* magazine's *Regional Design Annual,* AIGA 365, the *Type Directors Club Annual,* and many other publications and creative blogs. Currently teaching foundational and advanced typography classes at Chicago Portfolio School, he is also involved with the design mentoring program through AIGA Chicago (founded as American Institute of Graphic Arts and now known as AIGA, the professional association for design). Will is a graduate of Ringling College of Art and Design and holds a BFA in graphic and interactive communication.

HOW DID YOU GET INTERESTED IN DRAWING LETTERFORMS?

As a kid, reading Tolkien, playing fantasy games, looking at roughly sketched maps of made-up places—I loved the idea of having an alphabet all to myself, a secret language of sorts.

ARE THERE ANY PAGES THAT ARE ESPECIALLY SIGNIFICANT TO YOU?

The pages that continue to resonate with me are always the ones where I was at an emotional tipping point; mad, sad, frustrated, happy, etc. Those pages also tend to be the ones where the full page is used and played with. Once the space is filled, the moment has turned.

ARE THERE ANY CHILDHOOD MEMORIES THAT STICK OUT IN YOUR MIND THAT MAY HAVE IMPACTED YOUR ARTISTIC LIFE IN SOME WAY?

When I was very young, to help me fall asleep, my parents would read to me nearly every night. My dad would tell me stories and adventures, always starring our family dog, involving some epic mountain, cave, or forest that she would have to traverse. I visualized all of it. My imagination ran wild. It has definitely helped in what I do today—creating designs, layouts, and narratives using simple imagination and visualization.

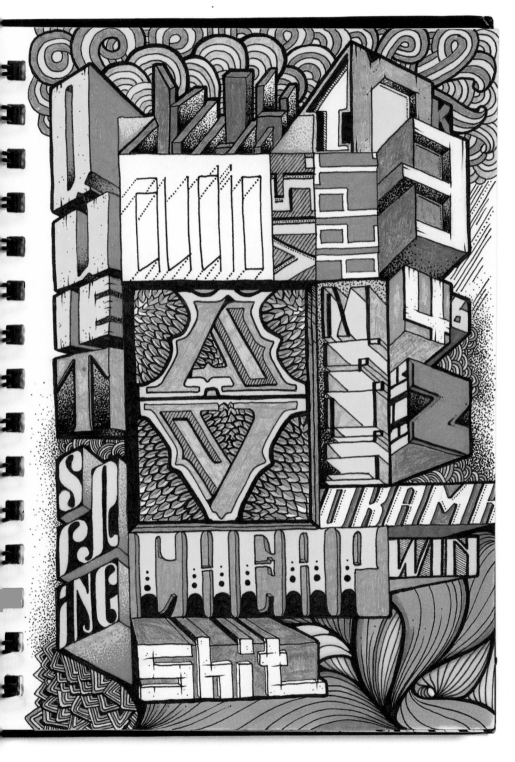

YOUR TYPE ILLUSTRATIONS ALWAYS FEEL SO THREE-DIMENSIONAL AND ARCHITECTURAL. DO YOU HAVE A BACKGROUND IN ARCHITECTURE?

I'm not sure how this approach started, but I've realized that living in Chicago, a city built on a grid, has propelled and influenced this energy. You start to see boxes everywhere. Your life becomes so modular. I'm traveling in X and Y all the time but living in Z every day. I've often wondered, in fifty years, when we have structures everywhere, will they be shaped like words? Will they transform into something fluid? Will they be part of the advertising messages we see every day? I'm definitely excited about the future of type and message. I took an architectural rendering elective course in school. At the time I was pretty excited to be drawing buildings in perspective. I guess I use that skill in a different way now. One that's closer to the medium or tools I work with in design. I wasn't going to be an architect, but I CAN render some interesting characters.

123

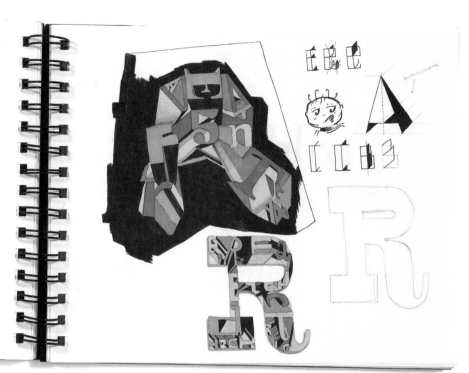

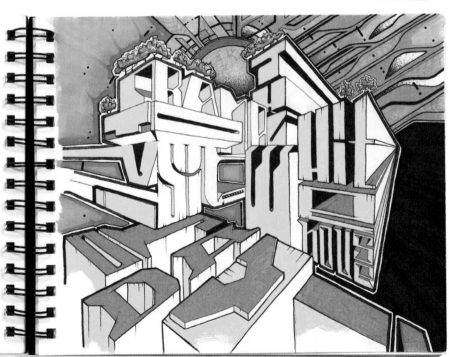

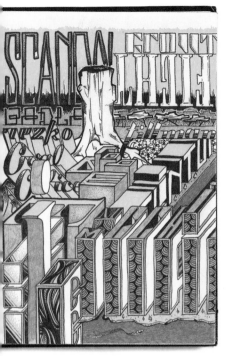

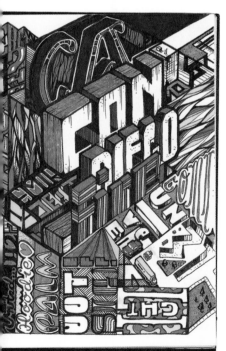

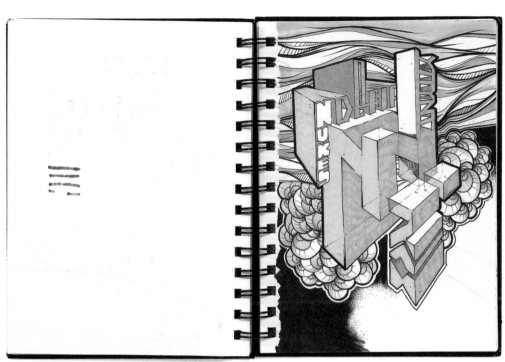

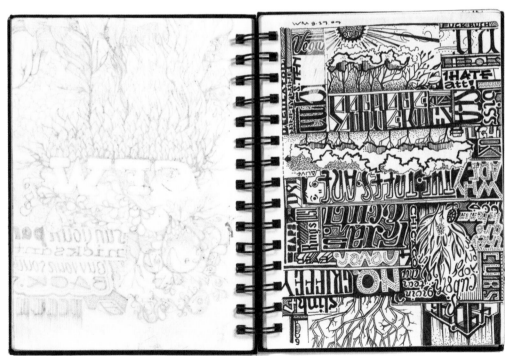

MARK MULRONEY

San Francisco, California
www.markmulroney.com

Mark Mulroney was born the same year Jimmy Carter took office. He is the offspring of two loving parents who made many sacrifices so that he could have a really great pile of LEGOS that he often used to build trucks that he would launch off the roof of his house. Several years later he married a super terrific girl and swore that he would never have any kids of his own.

WHAT ARE THE MAIN FUNCTIONS OF YOUR SKETCHBOOKS?

The basic function of my sketchbook is to be the backup hard drive to my brain. Everything I think I might forget goes into the book.

HOW DOES THE PROCESS OF CREATING SKETCHBOOK WORK DIFFER FROM CREATING YOUR MORE FINISHED PAINTINGS?

Lately there is no difference, but previously the sketchbook work was loose and carefree and the paintings got a bit stiff. I am working to eliminate divisions between how I approach canvas, paper, murals, and books.

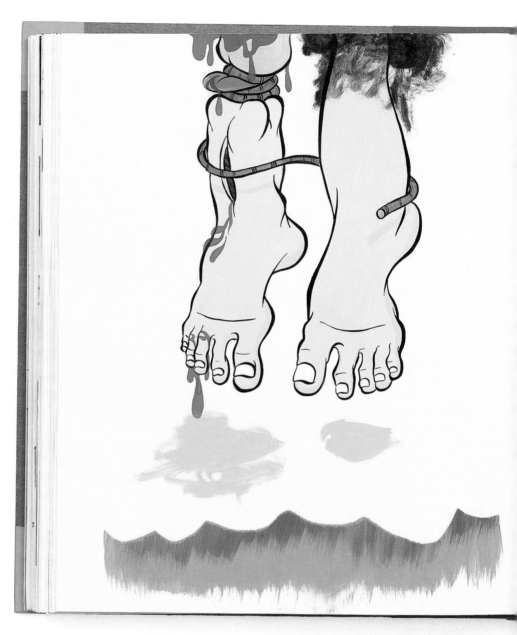

DO YOU REVISIT SKETCHBOOK PAGES, OR DO YOU WORK UNTIL THEY ARE FINISHED?

There is never a solid chronological order to the books. I often go back and forth and work on whatever page is open. Eventually, I run out of space and move on to the next book.

YOU SEEM TO ENJOY DRAWING A LOT OF X-RATED STUFF. I USED SOME OF THE CLEANEST PAGES I COULD FIND BUT STILL COULDN'T AVOID NAKED LADIES AND SPURTING BLOOD. WHY DO YOU LIKE DRAWING THIS KIND OF SUBJECT MATTER?

Catholic school did wonders for my imagination. There were so many great stories about people being tortured, mutilated, and burned alive. These unfortunate souls often did something horrible like have sex, so those activities have always been linked for me.

SOME OF YOUR DRAWINGS SEEM TO STYLISTICALLY REFERENCE COMIC STRIPS AND ANIMATIONS FROM THE 1930S AND '40S. WHAT DO YOU LIKE ABOUT THIS STYLE OF CHARACTER?

Cartoon characters used to have personality. It seems like many of today's cartoon characters get neutered pretty quickly by branding and marketing.

ARE THERE ANY CHILDHOOD MEMORIES THAT STICK OUT IN YOUR MIND THAT MAY HAVE IMPACTED YOUR ARTISTIC LIFE IN SOME WAY?

One time, when I was about five or six, I was at the beach and I saw my mom's pubic hair sneak beyond the borders of her swimsuit. I can't explain why, but seeing that made me aware that I was going to die. I think that had a pretty big impact on me and the type of work I make.

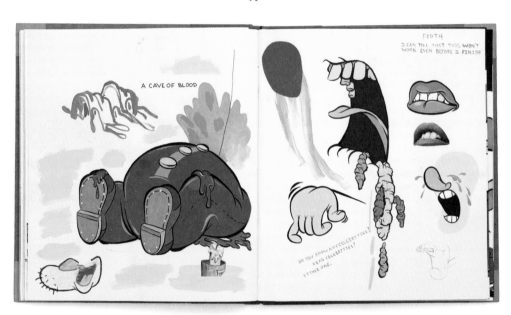

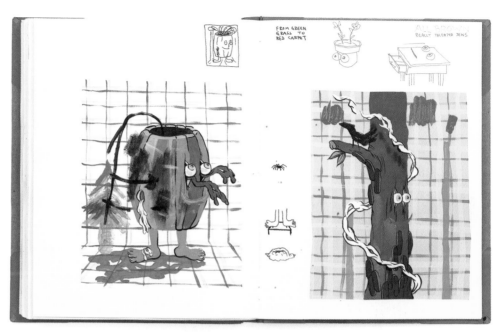

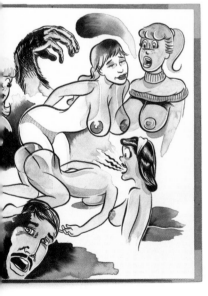

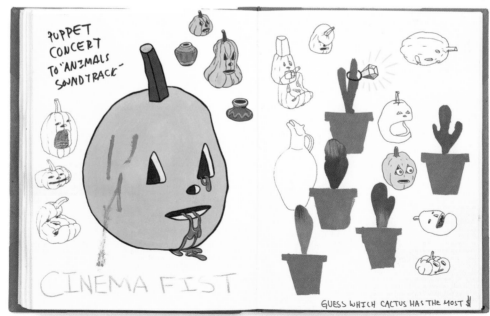

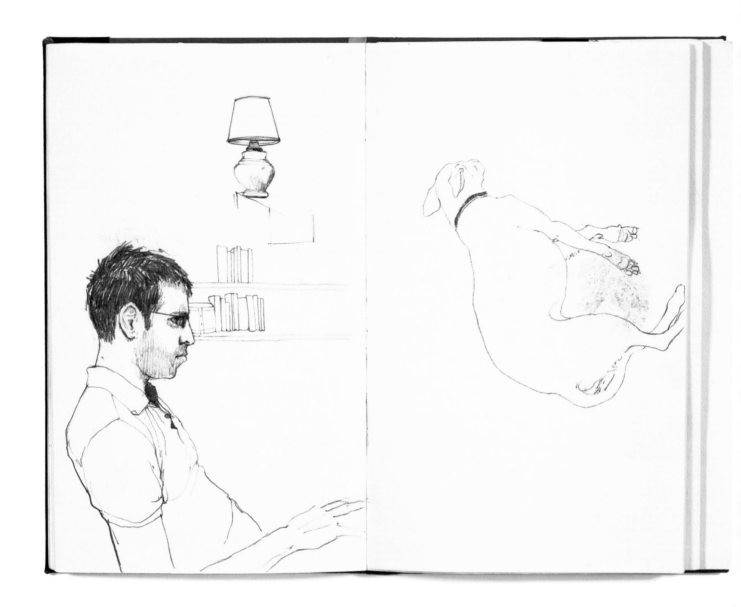

LAUREN NASSEF

Chicago, Illinois
www.laurennassef.com

Lauren Nassef was born in North Carolina and grew up in central Pennsylvania. She graduated from the Rhode Island School of Design with a BFA in painting in 2001. Now she is a freelance artist and illustrator living with her husband and shepherd mix on the south side of Chicago.

AS PART OF A SELF-DRIVEN PROJECT, YOU MAKE ONE DRAWING A DAY. HOW HAS THIS IMPACTED BOTH YOUR ARTISTIC AND YOUR PERSONAL LIFE?

I started the daily drawing project two months after I quit my day job and decided to become a freelance illustrator. Before the blog, I hadn't drawn regularly for more than five years. I thought I needed a way to structure my days, and I also hoped it would help me generate repeat traffic to my website. It turned out to be a perfect way for me to establish a personal style and to find a way to draw a lot without the pressure of having to make individual pieces that were "finished" or official or part of my professional portfolio. If I make something bad, I can always just do something better the next day. It's really been a lifesaver for me.

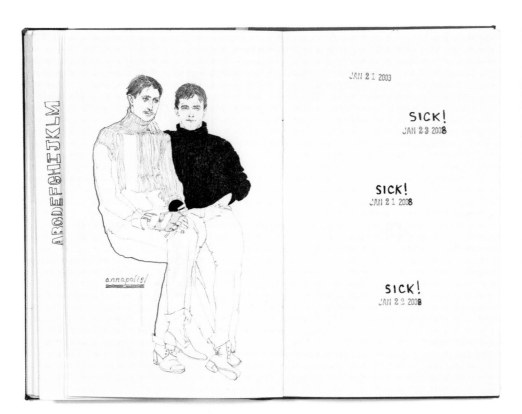

YOU MUST HAVE AMASSED A HUGE NUMBER OF DRAWINGS FROM THIS PROJECT. WHERE ARE THEY NOW? HOW DO YOU STORE THEM?

Yeah, I think I'm somewhere between 650 and 700 drawings now. They are all stored in drawers in a built-in buffet in my dining room. The graphite drawings are in between pages of hardbound black sketchbooks—you know, those common ones that are for sale in all the art supply stores. The ink drawings are in books with plastic sleeve pages. Each page is marked with one of those skinny Post-it notes that has the drawing title on it to help me find things when I need to. Sounds a lot more organized than it really is.

WOULD YOU SAY THERE ARE ANY HUGE OVERARCHING THEMES IN YOUR DAILY DRAWINGS? LONELINESS? STRANGE SITUATIONS?

I would say that there probably are, but that I have a very hard time pinning them down and honestly don't go looking for them. If I started to think about the daily drawings too seriously, I'd probably get frozen and stop doing them.

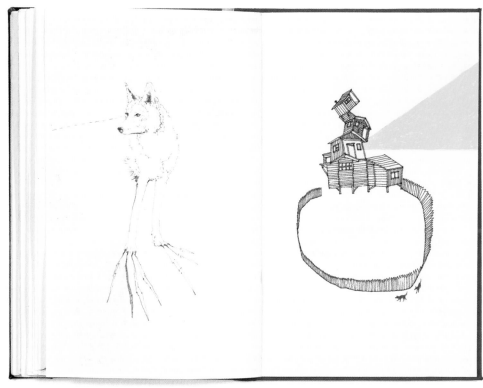

I basically just can't stand it when things get crowded. I think that the air around a drawing is as important as the drawing itself and that a fantastic little sketch can be ruined with the wrong margins. I break my own rule sometimes and run things off pages, especially for my commissioned illustrations, but if I always had it my way, everything would be floating in tons of space. I'm not sure what the effects of that are for the viewer. I guess it's different for everyone. For me, the empty space functions as a place to let my imagination fill in the rest of the story or something. It's more interactive that way.

ANDERS NILSEN

Chicago, Illinois
www.andersbrekhusnilsen.com

Anders Nilsen is the author and artist of several graphic novels and comics, including *Big Questions, The End,* and the Ignatz Award–winning, *Don't Go Where I Can't Follow* and *Dogs and Water.* He currently lives with his cat in Chicago.

WHEN DO YOU USE YOUR SKETCHBOOK?

Not very often at the moment. I'm too busy with other work right now. But generally, I work in it in between times—while waiting for someone in the car, while waiting at the airport. I try to always have it on me in case I get an idea because if I don't get the ideas down when they come, I won't remember them later.

HOW DID YOU GET INTERESTED IN DRAWING COMICS?

By reading them as a kid. Also by realizing, after art school, that making them was more fun and just as interesting as making elaborate installations in galleries that no one came to.

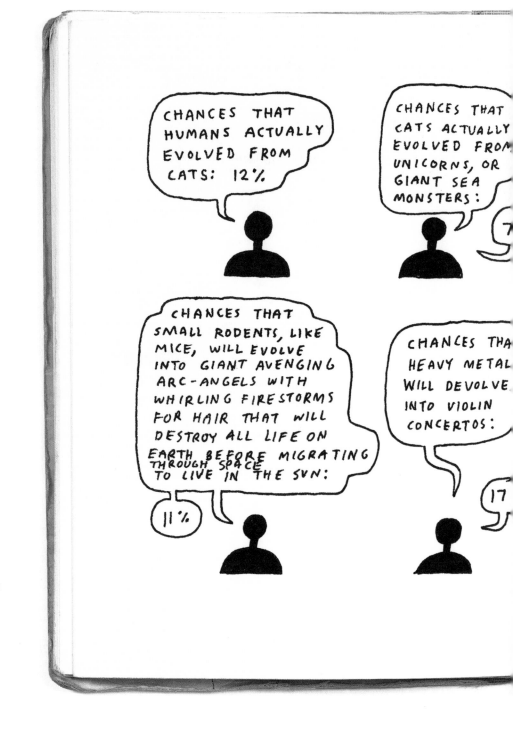

WHEN DID YOU GET YOUR FIRST SKETCHBOOK? AND WHAT DID THE DRAWINGS LOOK LIKE?

I've had them as long as I can remember. It was a usual Christmas or birthday present when I was a kid. The drawings changed a lot from page to page, but there were a lot of invented superheroes and weird cartoon characters, Dungeons and Dragons characters, and skateboarders. And probably a healthy number of skulls, band names, stuff like that.

ARE THERE ANY CHILDHOOD MEMORIES THAT STICK OUT IN YOUR MIND THAT MAY HAVE IMPACTED YOUR ARTISTIC LIFE IN SOME WAY?

My dad used to draw me and my sister when we were very young. His wife was an artist, too. So it was always around and seemed normal, and I was always encouraged. Otherwise, it was probably adolescence more than childhood that shaped my interests—discovering Pushead. My sister and I were both little punk rockers, and I remember seeing her friend's sketchbook, filled with dark, vaguely psychedelic pen drawings of skulls and tortured faces. I left the superheroes behind pretty quickly after that.

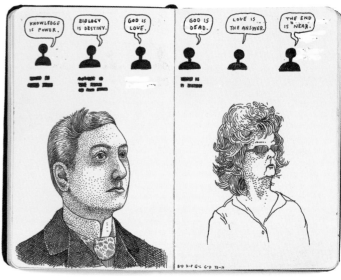

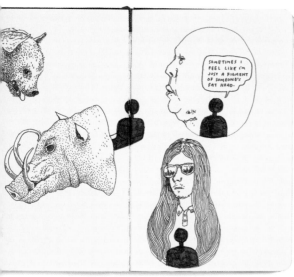

YOUR COMICS ARE REALLY WELL WRITTEN. DO YOU HAVE A BACKGROUND IN WRITING AT ALL? HOW MUCH DO YOU CONSIDER YOURSELF A WRITER AS WELL AS A COMIC ARTIST?

In one way, I consider myself both; in another way, I don't think of myself as either. I feel like being a "writer" means you are using words for their own inherent powers and properties. I don't really do any writing without thinking about how it interacts with the imagery it's connected to. I was once at a museum show in Denmark that paired comics with comic–influenced contemporary art. My girlfriend at the time, who is a food writer, was talking to one of the other cartoonists in the show, who asked her if she was a cartoonist, too. She said no, that she was a writer, at which point the other cartoonist declared indignantly that "cartoonists are writers"—and walked away. I think there are good reasons to make distinctions. And then to not take them too seriously.

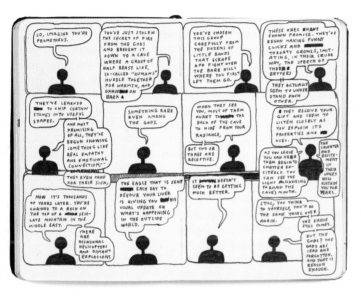

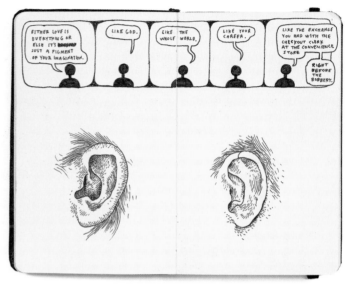

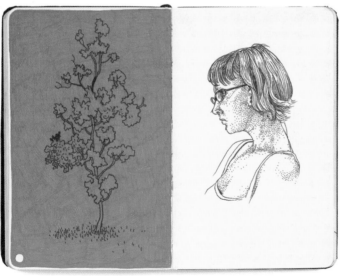

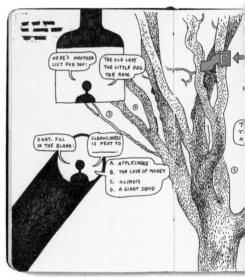

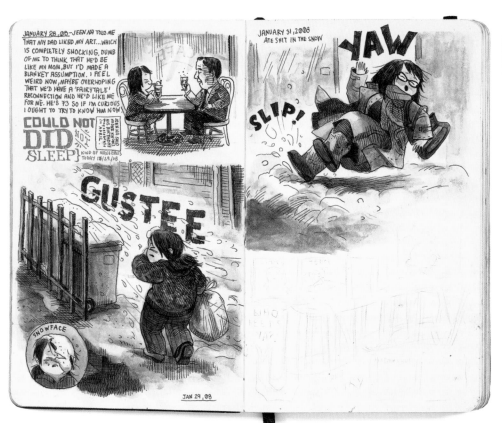

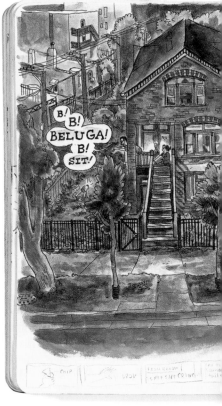

LAURA PARK

Chicago, Illinois
www.singingbones.com

Laura Park is a cartoonist and an illustrator and lives in Chicago. She is overly fond of birds and likes to have (at most) six kinds of mustard and (at least) five jars of marmalade on hand. For eleven years, she lived with the most amazing cat named Lewis. She is working on her first collected book of comics.

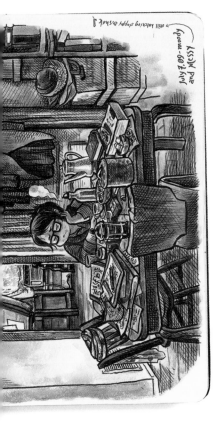

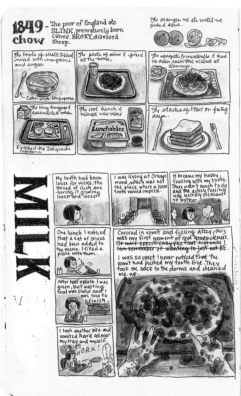

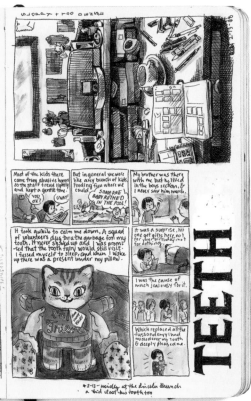

YOUR WORK IS SO AUTOBIOGRAPHICAL. DO YOU EVER RUN INTO TROUBLE SHARING SO MUCH OF YOUR PERSONAL LIFE?

I've always drawn little comics about my life and shared them with friends. I didn't realize when I started posting them online how awkward it could be. Far more people see them than I ever expected, but so far I've never gotten into any trouble. I don't share everything, though, and I make it a point to not share entries about friends who are much more private.

HOW MUCH OF YOUR SKETCHBOOK WORK BECOMES SOMETHING ELSE, LIKE COMIC PAGES?

It's hard to say, but probably about 80 percent. I doodle on scraps of paper, but when I work in my sketchbook, it's usually more focused.

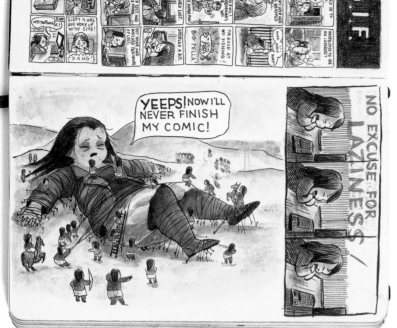

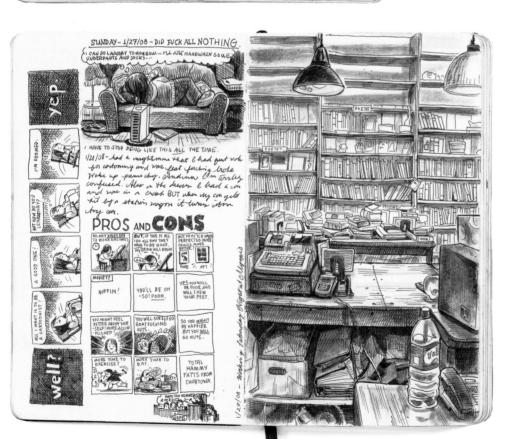

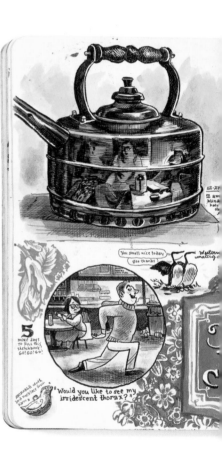

HOW MANY SKETCHBOOKS DO YOU HAVE?

I usually have one main sketchbook, a smaller one, and a lined journal going at the same time. I get restless and superstitious, so when one sketchbook feels "jinxy," I move on to another. I carry a few with me everywhere I go, along with a giant bag of pencils, pens, erasers, and watercoloring stuff. The finished sketchbooks are piled on a shelf in my studio.

ARE THERE ANY PAGES THAT ARE ESPECIALLY SIGNIFICANT TO YOU?

My dear cat, Lewis, just died. The pages that are significant to me now are the ones he appears on, which are almost all of them. It's a great comfort to see his face peeking out of the corner of a panel or the many scraggly drawings I did of him happily napping. I don't really take photos, so these drawings are what I have to remember him by.

WHEN AND WHERE ARE YOU USUALLY WORKING IN YOUR SKETCHBOOK?

I sketchbook all over the place. I used to draw at coffee shops for hours at a time. These days I usually work at home in my studio, which has the best light, but I also like making piles of papers and working on the dining room table where I can spread out. Drawing in bed on a rainy night is always soothing. Or in my big blue armchair on sunny mornings in the living room … I guess I'm not so picky about place or time.

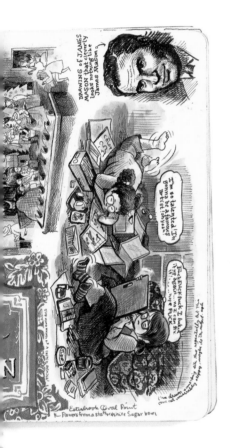

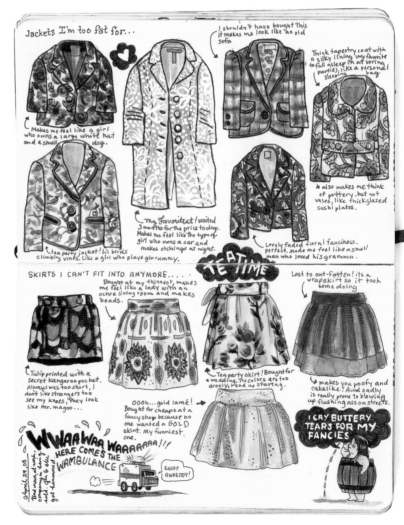

LEIF PARSONS

Brooklyn, New York
www.leifparsons.com

Leif Parsons, who also sometimes goes by Leif Low-beer, has been working as an artist and illustrator for a while now. He has shown work on both coasts and drawn himself naked a few times for the *New York Times*. He has recently been focused on trying to find the line between looseness and tightness, between deliberate idea and spontaneous expression, and between observation and imagination. Meanwhile, he does editorial illustrations for many of your favorite and not-so-favorite publications.

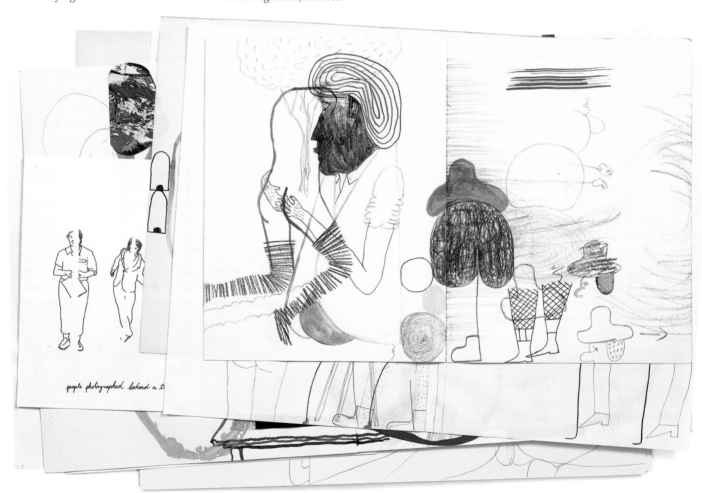

people photographed behind a t

YOU GAVE ME A BIG BOX FULL OF LOOSE DRAWINGS AND CALLED IT YOUR "SKETCHBOOK." PLEASE EXPLAIN.

Well … 1) I find I can keep myself looser and more open when I work in books where I can pull out the pages when I feel like it. 2) People always want to look through my sketchbook and it starts to feel precious, which tends to defeat the point. 3) I like to throw things away so I don't have to look at them anymore. 4) I often take my sketches and integrate them or use them as base drawings for final work. 5) I also like to organize them and attach them to other drawings to make new and unexpected ideas and narratives. 6) I also keep a notebook.

SOME OF THESE "SKETCHES" FEEL LIKE FINISHED DRAWINGS. HOW DO YOU DEFINE A SKETCH VERSUS A FINISHED PIECE?

I am excited about improvisation and often like people's sketches more than their final work. Keeping this in mind, I don't tend to differentiate sketching as its own activity, but generally approach all drawing with a goal of concentration coupled with staying open and spontaneous. The ones I passed on to you where a few that felt like they were in limbo, drawings that I had put aside as not resolved. (For commercial work, I don't really sketch except for the process of communicating my idea to a client.)

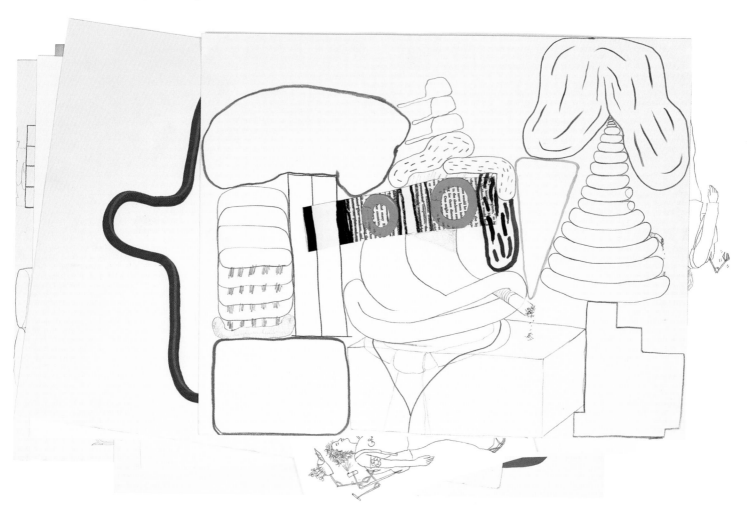

143

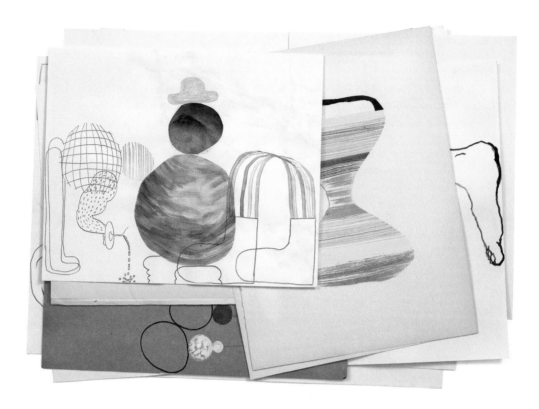

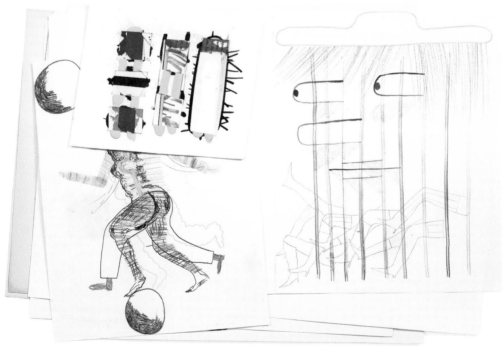

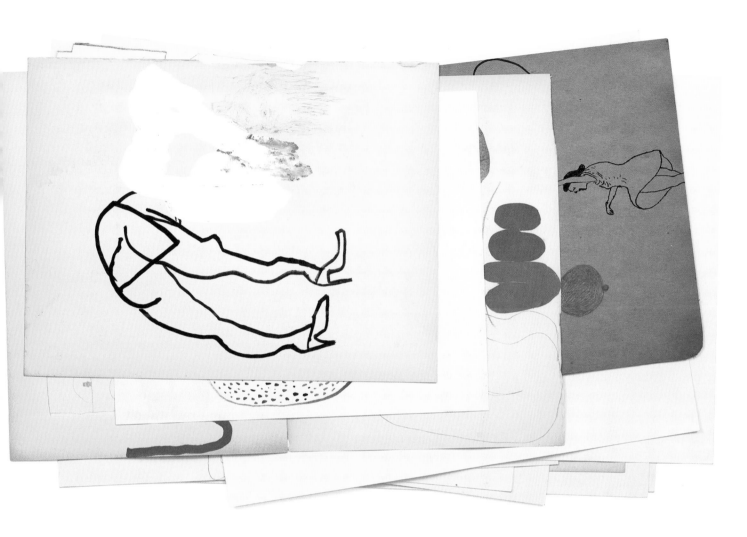

DO YOU REVISIT PAGES, OR DO YOU WORK UNTIL THEY ARE FINISHED?

I am often working on tons of drawings at the same time, both spread out on the floor and in the "working" section of my flat file. Sometimes they sit for days, months, even years; then I come back to them with a fresh vantage point and less fear. Essentially, I use an additive process until one day they are ether done or I wreck 'em.

YOUR WORK ALWAYS HAS SUCH A GREAT SENSE OF HUMOR. IS THIS A PART OF YOUR PERSONALITY THAT ONLY COMES OUT IN YOUR WORK OR WOULD YOU CONSIDER YOURSELF A "CLASS CLOWN" TYPE?

I have a quiet and possibly a bit of a negative sense of humor. Never a class clown but perhaps a little whisperer to whomever is nearby.

IF YOU COULD SEE INTO ANYONE'S SKETCHBOOK DEAD OR ALIVE, WHOSE WOULD IT BE?

Perhaps Guston …

CLAUDIA PEARSON

Brooklyn, New York
www.claudiapearson.com

Claudia Pearson is originally from London. Having traveled to the four corners of the world, she finally settled in New York and began her fifteen-year career as a commercial illustrator. She has had the pleasure of working with many esteemed publications, including *Elle, The New Yorker,* and the *New York Times,* to name just a few. In 2008, her first children's book, *Tribal Alphabet,* was published. The book won a Silver Moonbeam Award and The Stuart Brent Award for its contribution to promoting multicultural awareness in children's literature. The themes that have constantly connected her work over the years are people of all cultures, wonderful food, great music, and happy places.

WHEN DO YOU USE YOUR SKETCHBOOKS?

I tend to use my sketchbooks mostly when I travel or on public transport. On the subway I make sure the portraits are of either sleeping or reading individuals to avoid any crazy confrontations. Some of my most memorable moments traveling the world have been those quiet, solitary ones where I've found an inconspicuous corner to sit and record. The memories are far more enduring for me than taking a photograph. Inevitably, there are interactions with local people, and this sparks conversation or sign language, depending on where I am.

HOW MANY SKETCHBOOKS DO YOU HAVE? WHERE DO YOU KEEP THEM?

I must have about twenty, which are stacked on shelves in my studio. I know my mother has a few stowed away in her house in London from my early school days. Even back then the sketchbook traveled everywhere with me.

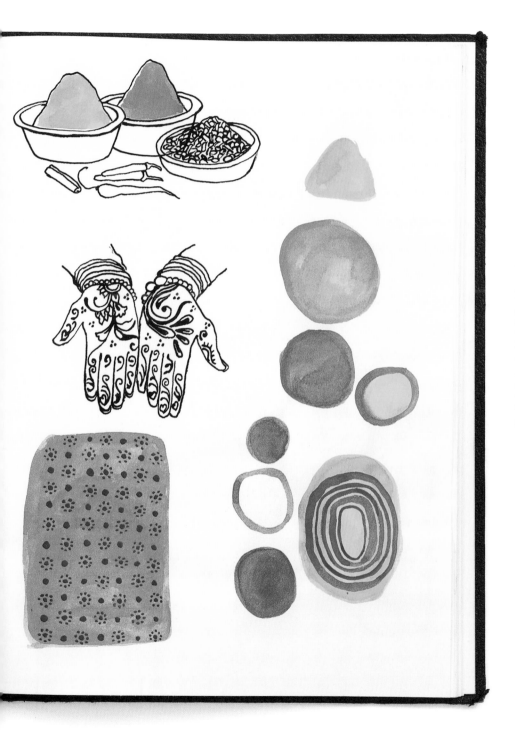

I think to go back to that first family trip and look over my early impressions of American culture. I obviously didn't know at the age of ten that I would end up living here. My mother moved from our childhood house last year, and I had to sort through all my old work. It stirred up some very vivid memories of what is was like to travel to New York in the early 1980s, and my love of Keith Haring and pop culture was evident in all those old sketchbooks.

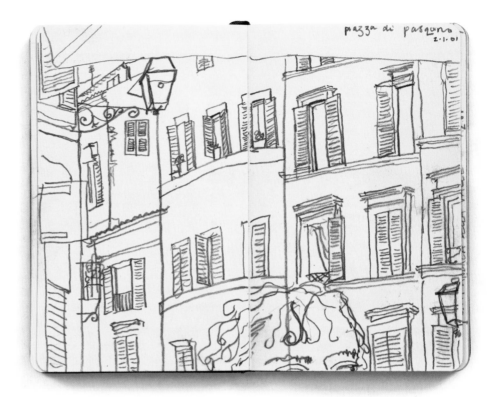

I NOTICED MANY OF YOUR SKETCHES SEEM TO BE DONE WHILE TRAVELING. WHAT ARE THE MOST INSPIRING PLACES YOUR SKETCHBOOK HAS GONE WITH YOU?

In 1998, I took five months off and bought a round-the-world ticket. During that time I painted a lot, but I think that Western Samoa holds the most memorable moments for me. I remember taking a choppy ferry crossing to an island and drawing some of the passengers. Their facial characteristics were so strong and unique.

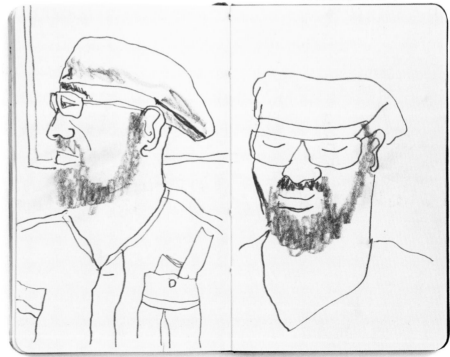

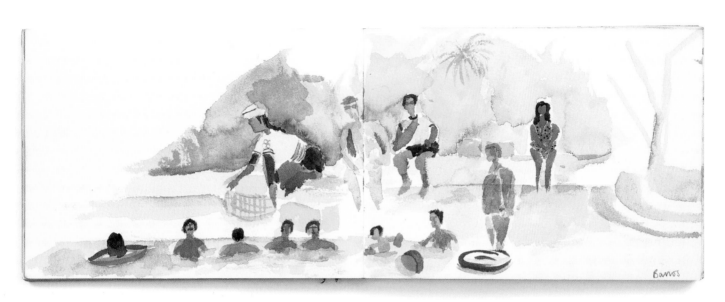

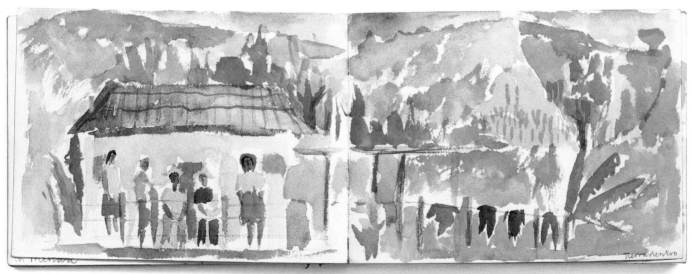

MIKE PERRY

Brooklyn, New York
www.mikeperrystudio.com

Mike Perry works in Brooklyn, New York, making books, magazines, newspapers, clothing, drawings, paintings, illustrations, and teaching whenever possible. His first book, *Hand Job*, published by Princeton Architectural Press, hit the bookshelves in 2006. "Mike Perry's compendium of hand-drawn type points to the continued relevance of the human touch in modern communication," wrote *American Craft,* October/November 2007. His second book, *Over & Over,* was released fall, 2008. He is currently working on two new books. In 2007, he started *Untitled Magazine,* which explores his current interests. The fifth issue came out in summer 2010. His clients include Apple, the *New York Times, Dwell* magazine, Target, Urban Outfitters, eMusic, and Nike. In 2004, he was chosen as one of *Step* magazine's 30 under 30; in 2007, he was selected as a groundbreaking illustrator by *Computer Arts Projects Magazine;* and in 2008, he received *Print* magazine's New Visual Artist award and the Art Directors Club Young Guns 6. Doodling away night and day, Mike creates new typefaces and sundry graphics that inevitably evolve into his new work, exercising the great belief that the generating of piles is the sincerest form of creative process. His work has been seen around the world, including a recent solo show in Minneapolis, Minnesota, titled "Lost in the Discovery of What Shapes the Mind."

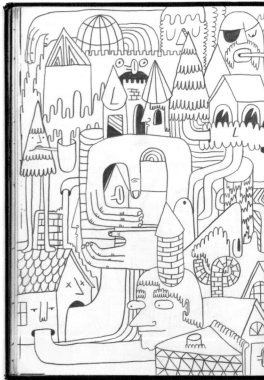

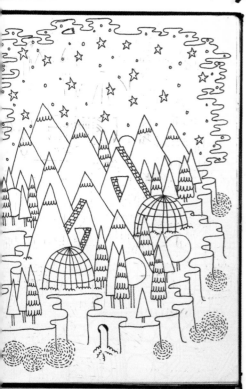

WHAT ARE THE MAIN FUNCTIONS OF YOUR SKETCHBOOKS?

I usually carry around three books: one for projects I am working on that is really loose and I fill it very quickly, a little Moleskine that has little doodles/lists/ideas, and a hardbound book that I take my time with.

YOUR WORK FEELS AMAZINGLY SPONTANEOUS—LIKE YOU JUST PICKED UP A PEN AND STARTED AND THAT'S WHAT CAME OUT. IS THIS HOW IT REALLY HAPPENS OR IS THERE SOME PROCESS BEHIND IT THAT YOU ARE ABLE TO DISGUISE?

It depends on the project. My overall strategy is just to always be working so that when a project comes along I am in the flow. And the work is changing day to day. Sometimes it is organic sketchbook pages scanned and turned into screen prints. Sometimes they are doodles that are redeveloped and put into a larger context. I also get obsessed with a shape or color and work it to death, then move on.

HOW DID GROWING UP IN AND AROUND KANSAS CITY AFFECT YOUR WORK?

I used to go into the fields behind my house and paint landscapes. But the biggest effect it had on me was that I was pretty bored, so I made my own excitement, which equaled a lot of work.

YOU'VE WORKED ON ALL SORTS OF PROJECTS, BOTH 2-D AND 3-D, FROM CREATING MAGAZINES TO CONSTRUCTING ENORMOUS LETTERS TO WRITING POEMS. OUT OF ALL THESE VERY DIFFERENT KINDS OF PROJECTS, WHICH TYPES ARE THE MOST CHALLENGING?

The 3-D stuff is the hardest because I don't know how to make the ideas I have. So much of my work comes because I feel confident in my ability to make anything that is 2-D. I am working through that and educating myself. Luckily, I have friends that are very handy.

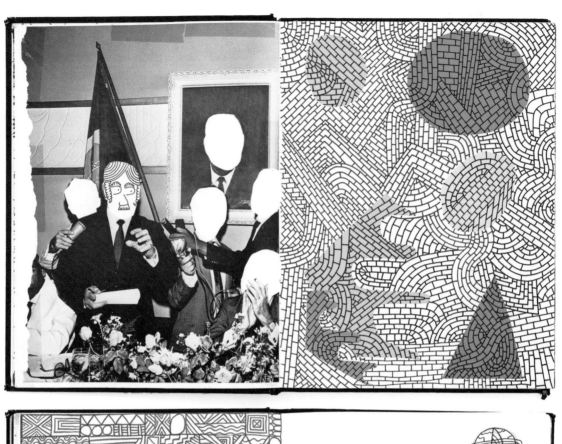

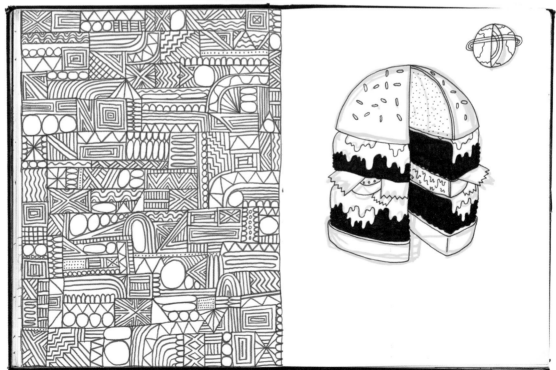

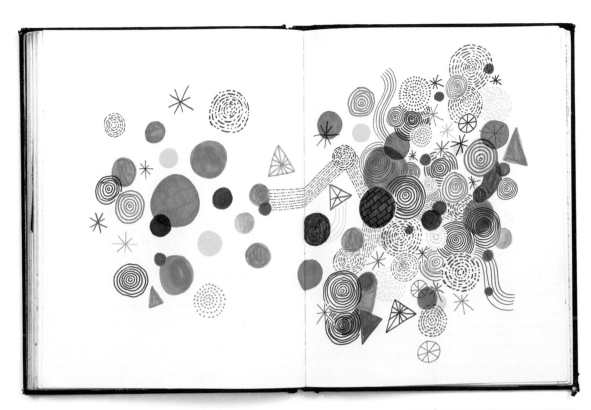

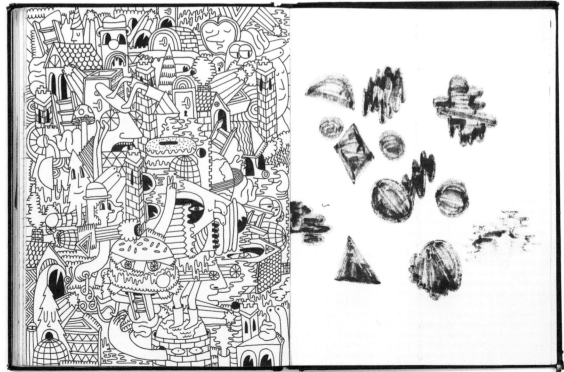

JULIA POTT

London, England
www.juliapott.com

When Julia Pott was younger, she wanted to be a balloon. Unfortunately, that dream fell through and now she is a freelance illustrator and animator based in East London. Her work tends to explore the motivations behind human relationships, representing characters as mildly ridiculous anthropomorthic animals. Currently completing an MA in animation at the Royal College of Art, she is also part of the animation collective Treat Studios. Clients include Bat for Lashes, The Decemberists, Etsy, Skins, Casiotone for the Painfully Alone, Malibu Rum, Toyota, and Picador.

DO YOU HAVE PETS?

No, not yet. I have been thinking about getting a dog when I move to New York next year, but I killed seven hamsters when I was a kid, so I'm thinking very seriously about my abilities as an animal parent!

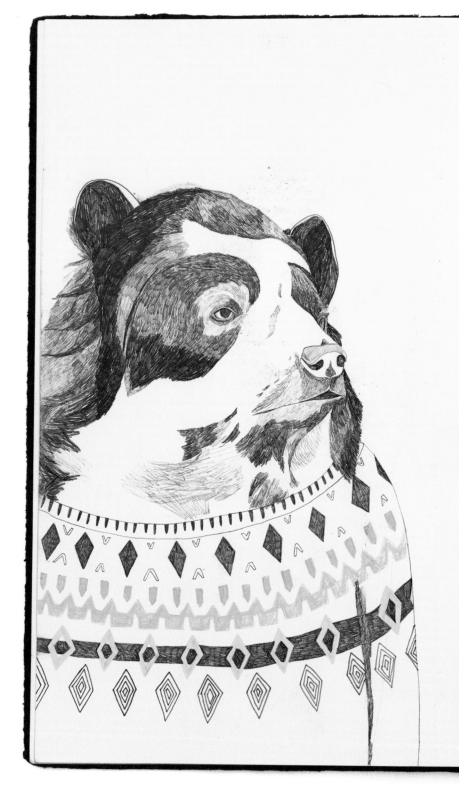

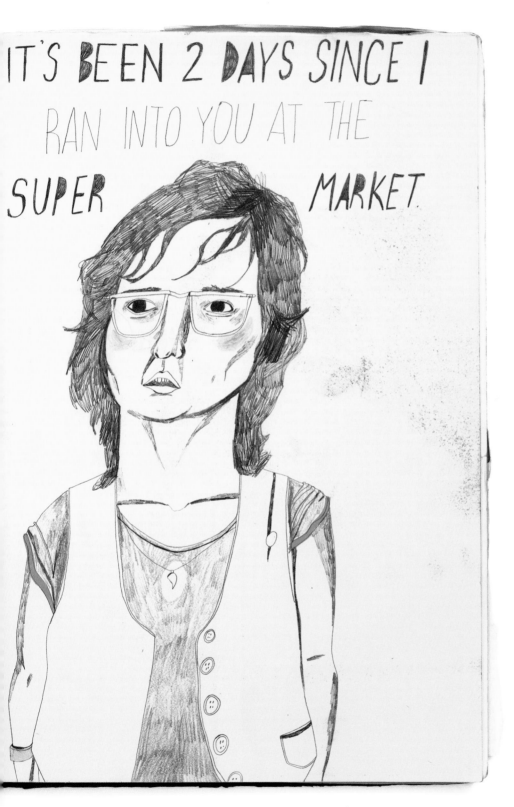

IT'S BEEN 2 DAYS SINCE I RAN INTO YOU AT THE SUPER MARKET.

IT SEEMS THAT YOU OFTEN LIKE DRAWING ANIMALS, WHETHER THEY ARE IN THEIR NATURAL STATE OR PERSONIFIED. WHY DO YOU PREFER DRAWING ANIMALS?

I'm not really sure. I think when I was in my third year at university everyone was drawing stylized people, and I wanted to do something slightly different. I had been drawing people all through college, and so animals were a change for me. Now it seems that whenever I draw people I'm breaking out of my style, which is nice! I think I prefer drawing animals because I find a humor in them, and I use them as representations of myself, as corny as that sounds.

BESIDES ANIMALS, HAVE YOU NOTICED RECURRING THEMES IN YOUR SKETCHBOOKS?

I tend to focus a lot on human relationships in my work, dealing with things that are going on in my life. I also love drawing mountains and trees and geometric shapes. I went through a phase where I used to put old photographs of my mom as a kid in my drawings. She loved that!

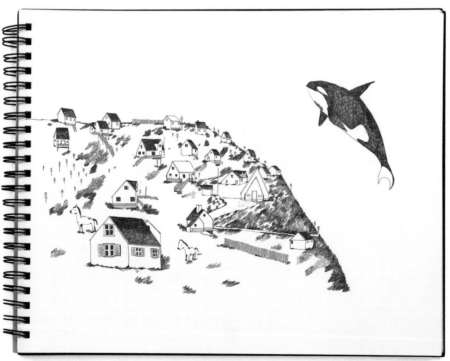

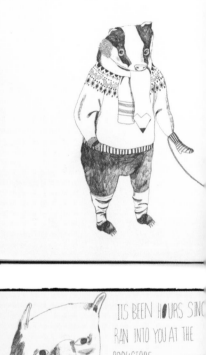

ITS BEEN HOURS SINCE
RAN INTO YOU AT THE
BOOKSTORE. _____

- AIRING YOUR DIRTY LAUNDRY
- A SWIMMING POOL
- SHOWING A PROCESS "HOW TO MAKE A BUTTON" BUT
 MAKE IT UNIQUE IN A NEW IMAGINARY WAY
- SMALL, SLOW, AWARD "ARE YOU ANYBODY'S
 FAVORITE PERSON"
- IMAGINING OUR FUTURE IN MICROSCOPIC
 DETAIL.
- OPEN YOUR MOUTH, THINGS COME OUT.

MOUNTAINS
COLLAGE
MONTAGE SCENE
- THE END OF SOMETHING
- DARK PITS OF TEA SIPPING ILE
- A MAN WITH A BEAR HAT
- A SMALL VS BIG CHARACTER
- AMERICAN INDIANS - VS PILGRIMS
- GET MOM + DAD TO SIT DOWN +
- CONTROVERSIAL SUBJECTS:
 - CHRISTMAS
 - FOOTBALL
 - HOW THEY MET. (

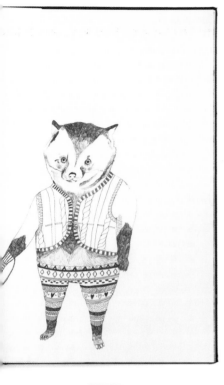

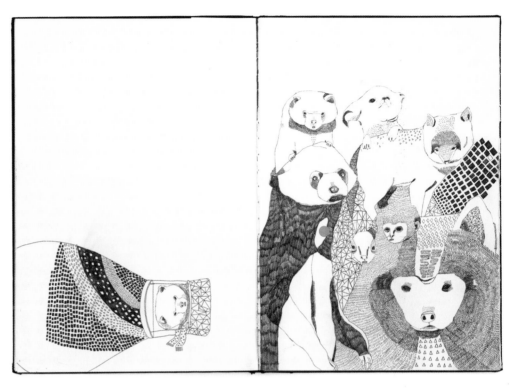

OH, I DIDN'T EXPECT TO SEE YOU.

WHEN DID YOU GET YOUR FIRST SKETCHBOOK?

I actually found my first sketchbook in my grandma's house in New York a year or so ago. It was from when I was about four years old, and I just kept drawing the same family again and again posed in family photos. It's really bizarre, actually. And then I found one page that just said in big felt-tip marker: "telly yes me you babby." God knows what that means. I guess I was a weird kid!

WHERE DO YOU USUALLY SIT WHEN WORKING IN YOUR SKETCHBOOK?

At my desk, which is in front of a big window. It has great light, and you can see the park and some trees right out of my window, so it's very calming. Sometimes I'll draw in front of the TV if I'm feeling a little lazy, but mainly I'll be listening to the radio and drinking a big cup of tea.

CATELL RONCA

London, England
www.catellronca.co.uk

Catell Ronca was born in Switzerland and lives in London. She works for a variety of international clients and has most notably created a set of six stamps for the British Royal Mail. She also teaches illustration at various universities across the United Kingdom. She loves traveling, observing people, her two cats, and cooking.

HOW MANY SKETCHBOOKS DO YOU HAVE? WHERE DO YOU KEEP THEM?

I don't really know … since I started studying illustration, it must be in the region of forty. The most important ones are the most recent … the last 10 or so. There are many that I don't feel are so relevant to me anymore, yet I could never bring myself to throw them away.

ARE YOU USUALLY DOING ANYTHING ELSE WHILE DRAWING IN YOUR SKETCHBOOK? LISTENING TO MUSIC? WATCHING TELEVISION?

I love listening to someone talking about intelligent and informative stuff on the radio or even better, an audio book or a play. I can always look at a page of my sketchbook and remember what I had been listening to at the time.

I NOTICED YOUR AMAZINGLY BRIGHT, SATURATED PALETTES. HOW DO YOU PICK COLORS FOR YOUR PROJECTS?

Well, it is often a very instinctive affair as I'm always looking for a certain emotion. I do have my favorites that I always gravitate toward, such as the primaries and pinks. Then I try to combine these with muted earthy colors to achieve a certain feel.

IS THERE A SPECIFIC TYPE OF BOOK YOU PREFER TO USE AS A SKETCHBOOK?

Yes. For my paintings, I really love the square and chunky book by Seawhite of Brighton. I also really like to have space for my paintings as I paint rather big, so I also use the A3 one. I am quite particular about the paper too. It has got to be quite heavy. There is nothing worse than when it curls up.

WHERE DO YOU USUALLY SIT WHEN WORKING IN YOUR SKETCHBOOK?

In my studio, but I also like to use the time when I travel around London on the bus and train to sketch.

HOW DOES IT FEEL TO LOOK AT OLD SKETCHBOOKS?

It's always a lovely and positive experience since I always forget how much work I put into them. I can always gain something from looking at them, and it makes me want to produce more. Interestingly, I never get the same feeling when I re-read my own written word—it always makes me cringe when I read my own texts.

Sugar

Sugar Sugar

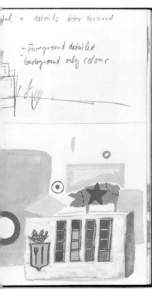

...ul + details after sketched

- Foreground detailed
 background only colour

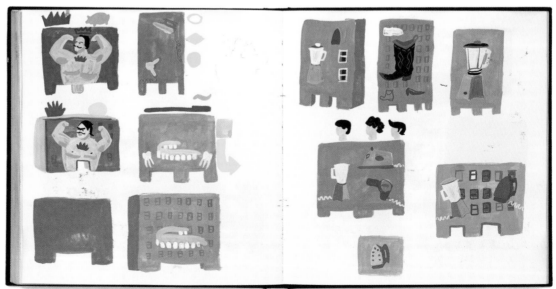

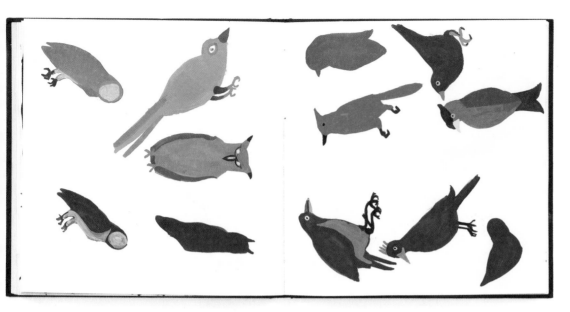

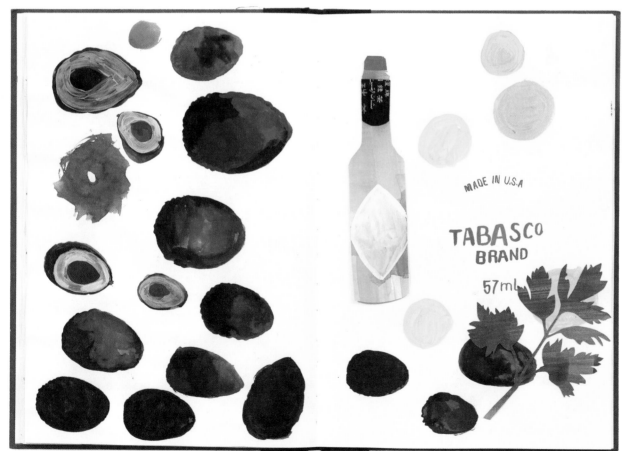

MADE IN U.S.A

TABASCO
BRAND

57mL

161

JULIA ROTHMAN

Brooklyn, New York
www.juliarothman.com

Julia Rothman is an illustrator, a pattern designer and now an author of two books. She is also one-third of the design company ALSO and runs a blog called *Book By Its Cover*. She lives and works in Brooklyn, New York.

WHAT ARE THE MAIN FUNCTIONS OF YOUR SKETCHBOOKS?

I have two kinds of sketchbooks. First, I use big spiral-bound sketchbooks for drawing everything that goes into my illustrations and pattern designs. I draw everything in pen and scan them into the computer where they get colored and arranged for my designs. I have about twenty of these completely filled with line work. Then I have other sketchbooks which I have made myself, long accordion books made of thick fancy paper which I paint and draw into. These have more finished looking work in them. Usually these are drawings from life, of friends or scenes around me.

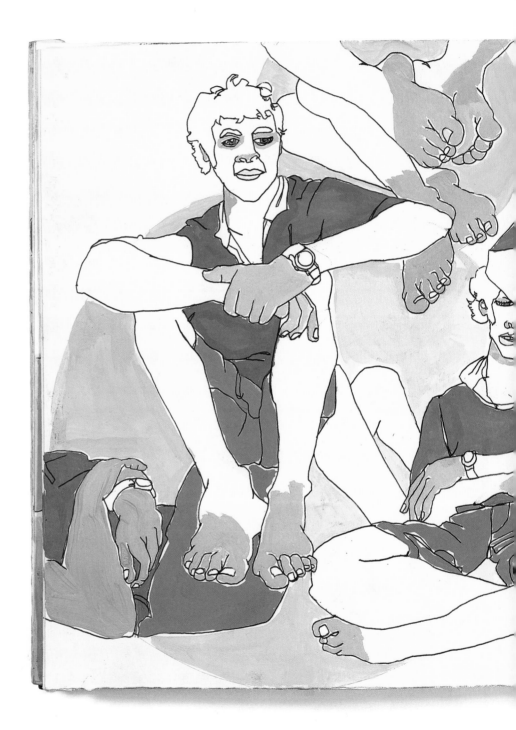

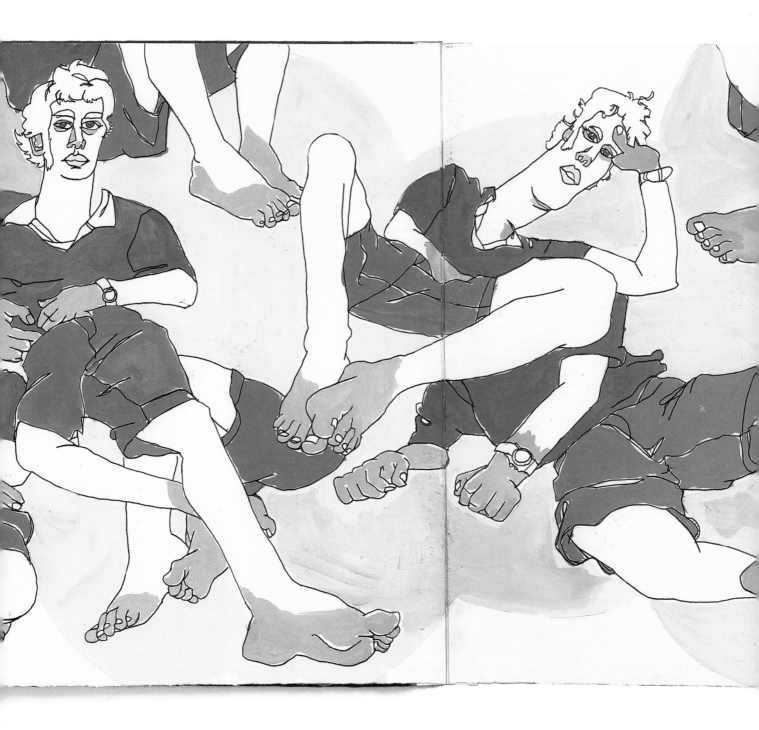

WAS THERE A TIME WHEN YOU USED YOUR SKETCHBOOK MORE OFTEN?

In my junior year of college, I went on a summer session trip to Cuba. The class was on poster design, but really we just studied Cuban culture and toured the country. I drew in my sketchbook constantly during that trip trying to record everything around me. I also used it as an excuse to have some alone time because we were with the same group of students 24/7 for four weeks, so it got intense. I was still developing my own personal drawing style before that trip, but I think working in that sketchbook so much helped me figure it out.

WHEN DID YOU GET YOUR FIRST SKETCHBOOK?

My mom got me my first sketchbook in maybe fourth or fifth grade. It was a classic hardcover black book. I used it to copy cartoon characters I liked into it. I drew Garfield a lot, copying the different poses from my bed sheets, or Disney characters from the video cassette box. I would color them lightly with colored pencil. I was always copying or tracing drawings I saw around me. I guess that's how I learned to draw.

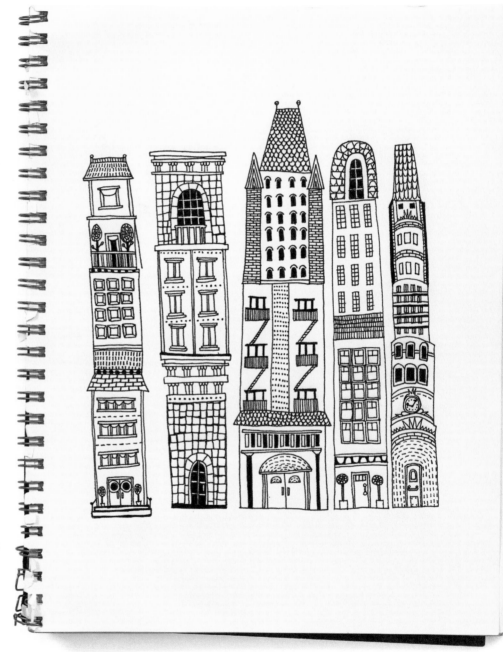

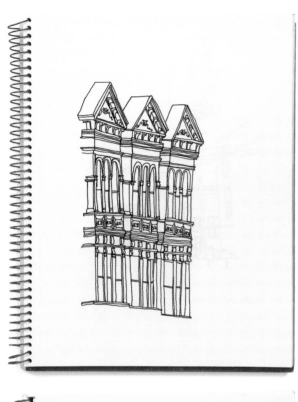

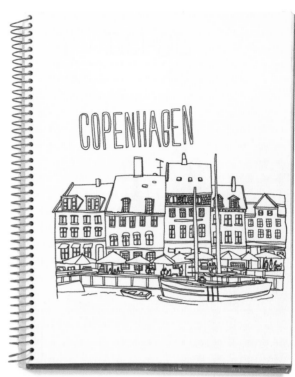

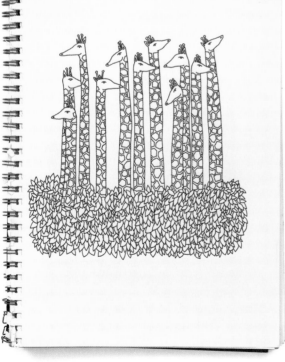

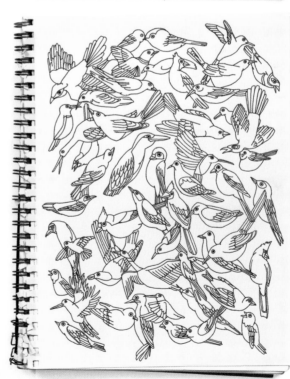

CARMEN SEGOVIA

Barcelona, Spain
www.carmensegovia.net

Carmen Segovia is an artist and an illustrator who grew up between a green and quiet Barcelona suburb and a brown and very quiet Almeria village in Spain. She went to cinema, created set designs, and attended arts and crafts schools. She currently lives in Barcelona and works as an illustrator for clients around the world. In addition to her illustration work, she regularly publishes picture books, collaborates with music bands, and develops drawing and painting series. She is represented in the United States by Marlena Agency.

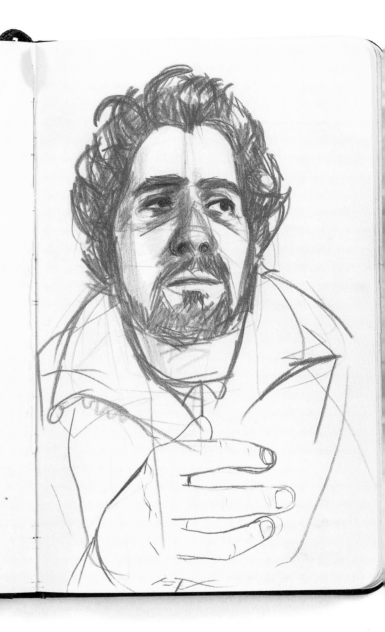

ARE THERE ANY PAGES THAT ARE ESPECIALLY SIGNIFICANT TO YOU?

I have a sketchbook filled with variations of the same scene: anthropomorfic animals playing in a wood enclosed by two trees. I got the inspiration in a fairy tales book, beautifully bound, from the '70s, that I bought in Tallin (Estonia).

These sketchbook pages were the genesis of a painting exhibition I did that meant a change of color palette to me.
That was a neat one, but I lost it!

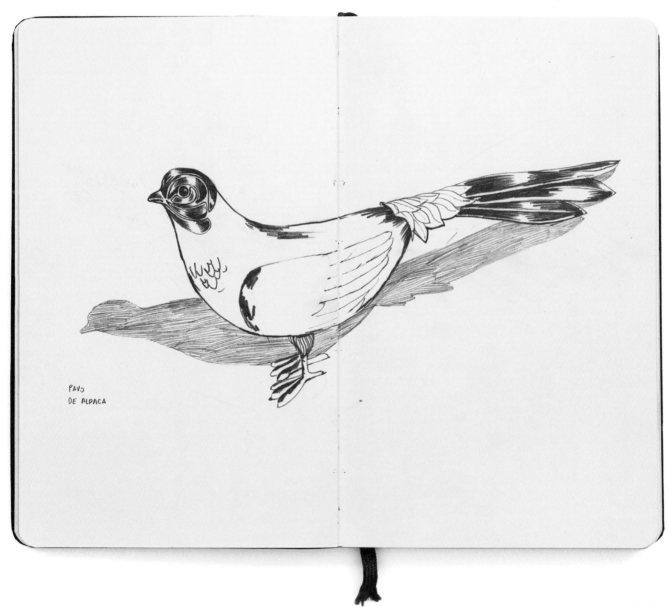

PAVO
DE ALPACA

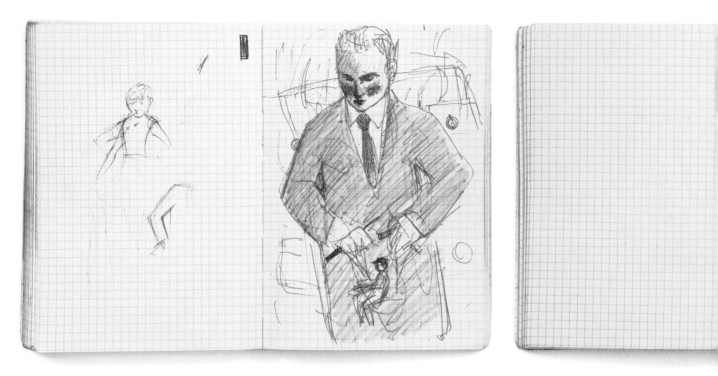

WHEN DO YOU USE YOUR SKETCHBOOKS?

I mostly use sketchbooks when I start thinking about a new project or an idea. I write, doodle, and rough compositions or character designs. I also use a sketchbook when I travel. I like to draw objects or stuff that I find interesting somehow. I use sketchbooks as a step toward another place. I don't treat them like an object per se, an "artist book," although I really love other artists' gorgeous, spectacular, big, and colorful sketchbooks. I would really like to have "firework" sketchbooks, but mine tend to be hopelessly tiny, messy, and filled with plenty of unintelligible lines. If I need to, I also use the sketchbook to write down the shopping list, but I'm trying to quit that!

ARE THERE ANY CHILDHOOD MEMORIES THAT STICK OUT IN YOUR MIND THAT MAY HAVE INFLUENCED YOUR ARTISTIC LIFE IN SOME WAY?

I remember one summer I kept chasing all my family, friends, and whoever set foot in my house to sit down so I could draw their portraits. I didn't want to sell the portraits to them (like some of my friends did!), but I just remember enjoying doing that.

WHAT IS YOUR FAVORITE COLOR COMBINATION?

Gray and pink.

LIZZY STEWART

Edinburgh, Scotland
www.abouttoday.co.uk

Lizzy Stewart lives and works in Edinburgh, Scotland, although she's originally from South Devon at the the other end of the country. Her work is often informed by a love of modern-European history, folk music, and literature, as well as the beautiful city she lives in and the ideas she has riding on buses back and forth across it. She is also one-half of independent publishers Sing Statistics, which has two books due for release in 2011.

IT SEEMS LIKE A LOT OF YOUR DRAWINGS ARE FROM ANOTHER TIME. IS THERE A SPECIFIC PERIOD IN HISTORY YOU LIKE TO REFERENCE IN YOUR WORK?

I love early-twentieth-century history and photography. That definitely creeps into my work every now and again. I love old portrait photography, mainly of women. I love seeing how fashions changed and how beauty alters from decade to decade.

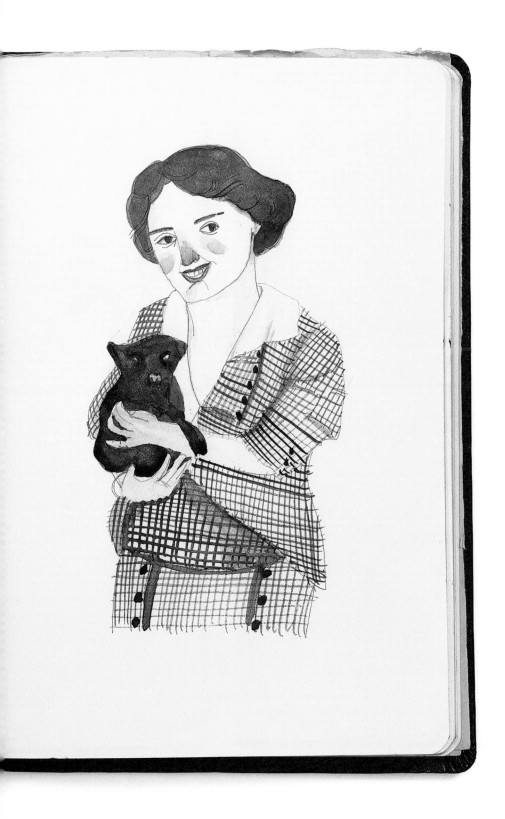

It's funny; I've never thought about this until this very second, but now that I do, one sticks out so vividly that I can't believe I haven't pinpointed it before. When I was very young, maybe about six or seven, I remember sitting at my grandma's dining table drawing on a stack of cheap white A4 paper. My grandma and mum were opposite, and my grandma suggested I draw her. I did (and I can vividly remember the drawing), and I tried really, really hard to get it right. When I'd finished, she commented that I'd drawn it really accurately, and she noted that I'd taken into account the real shape of her head (rather than just a circle as most kids do), where her ears were, and her neck and that that was really clever of me! I was so proud and over the moon to have impressed her. She died when I was nine, but I think her encouragement back then really got me going. She was the first person to say that I was good at drawing (after my parents!).

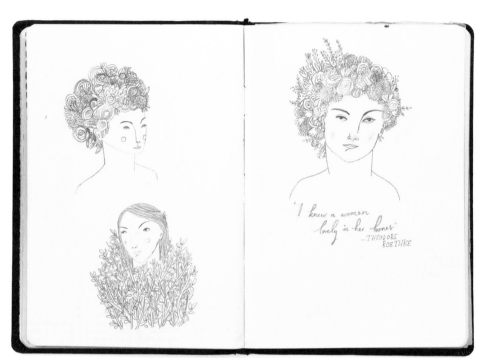

"I knew a woman
lovely in her bones."
—THEODORE
ROETHKE

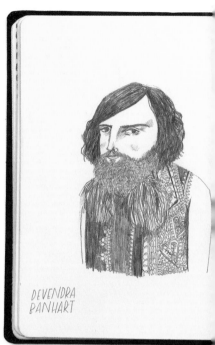

DEVENDRA
BANHART

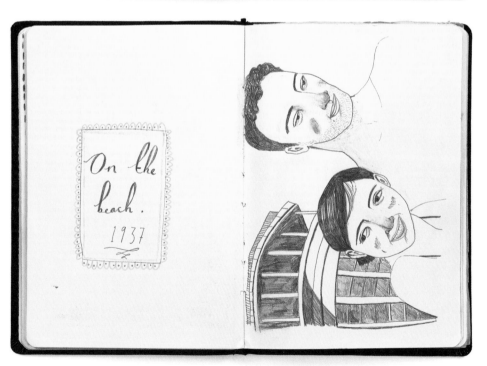

On the
beach.
1937

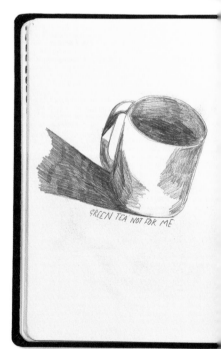

GREEN TEA NOT FOR ME

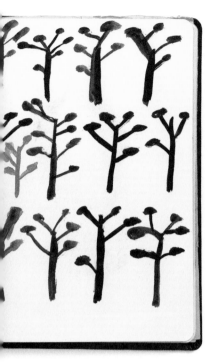

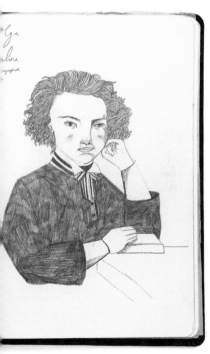

WHAT ARE THE MAIN FUNCTIONS OF YOUR SKETCHBOOKS?

My sketchbooks are pure self-indulgence. I use them for drawing the things I'm interested in and the stuff that gets me visually excited. I like to keep them as diaries of what I'm thinking about. When I was a teenager, I drew various film heartthrobs. Now it's foreign buildings and lines from songs and books. Oh, and I usually keep notes and phone numbers and to-do lists in the back, although I always plan not to—I just always forget to carry a separate notebook. In a way, it sort of makes the sketchbook even more of a specific period. It also serves to contrast the orderliness of my drawing with the manic scrawl of my note-taking.

WHEN DID YOU GET YOUR FIRST SKETCHBOOK?

When I was six, I won the consolation prize in a runner-bean growing competition at my school. (I grew the smallest bean … the goal was to grow huge ones … I guess maybe it's a UK thing?) I won a sketchbook and some felt-tip pens. That was the first one I remember owning. I started keeping a sketchbook properly when I was twelve, I think. I got through two or three per year in high school, and I have them all stored away safely. They make me cringe when I look at them now, but the practice of keeping one going was important to me and definitely shaped the way I use my sketchbooks now. I recently gave my ten-year-old cousin one of my spare sketchbooks when we were on holiday. He rapidly started filling it up. I hope he's caught the bug!

MIKE SUDAL

Harrison, New York
www.mikesudal.com

Mike Sudal draws and diagrams a lot of crazy stuff, from historical battles to oceanic scenes and the occasional toilet (yes, it's true). He received his BFA in illustration from Ringling College of Art and Design in 2002. Since college, he has been illustrating, researching, writing, and designing his own informational graphics, which supplies him with a lot of random facts for the dinner table. His staff jobs include the *St. Petersburg Times,* Asbury Park Press, and more recently the Associated Press. Some freelance clients include *Field & Stream, Boating Life,* The Nature Conservancy, Pfizer, and Syngenta. He also fishes way too much.

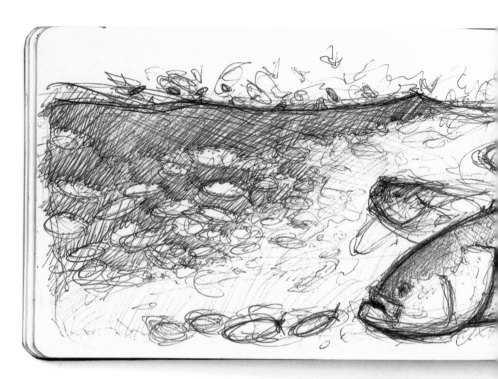

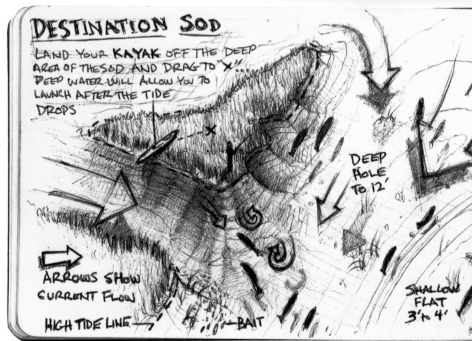

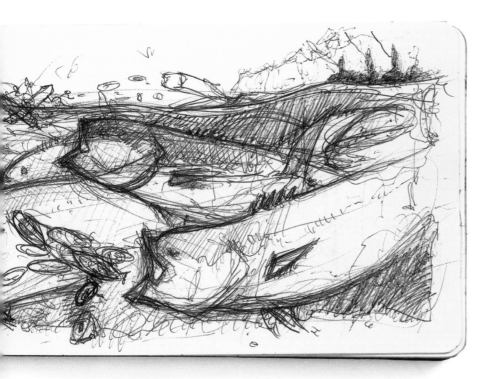

I've been fishing my whole life and do everything from flyfishing for trout and bass to surf and kayak fishing for saltwater species. My passion for it is a bit over-the-top, but for that I have no excuse. I guess if we were cavemen I would be one popular dude in the group. I currently spend most of my time surfcasting Montauk Point and elsewhere on Long Island. I fish at night wearing a wetsuit, which allows me to swim to spots I can't reach from shore, where the bigger fish hide. It's definitely extreme. During the height of the season, I try to get out multiple times a week.

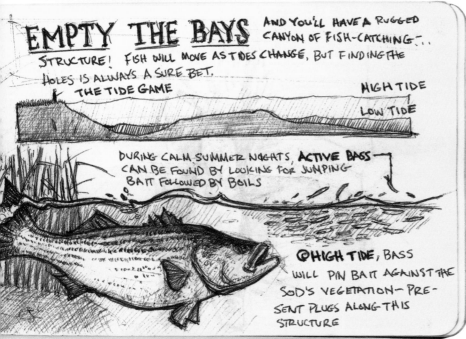

EMPTY THE BAYS AND YOU'LL HAVE A RUGGED CANYON OF FISH-CATCHING...

STRUCTURE! FISH WILL MOVE AS TIDES CHANGE, BUT FINDING THE HOLES IS ALWAYS A SURE BET.

THE TIDE GAME

HIGH TIDE

LOW TIDE

DURING CALM SUMMER NIGHTS, **ACTIVE BASS** CAN BE FOUND BY LOOKING FOR JUMPING BAIT FOLLOWED BY BOILS

@HIGH TIDE, BASS WILL PIN BAIT AGAINST THE SOD'S VEGETATION - PRESENT PLUGS ALONG THIS STRUCTURE

SOME OF THE DRAWINGS IN YOUR SKETCHBOOK ARE INFORMATIONAL AND TEACH ABOUT GOOD FISHING TECHNIQUES. ARE THESE STUDIES FOR A BIGGER PROJECT OR ARE THESE DRAWINGS JUST FOR FUN?

They're a bit of both, actually. I've been drawing my personal fishing techniques ever since I was a kid. It's common for fishermen to keep journals detailing each trip they take to learn patterns that help catch more fish, and I always took it a bit further by drawing my tactics and spots rather then just taking notes. In doing this, I can look back in a journal and see what tactics worked best for the fish I'm targeting. In the professional field, I revisit my sketches often when diagraming outdoor techniques for clients. I like to pick little details from them to make the final illustrations a bit more realistic. It may be as simple as adding a cool piece of driftwood or a few different birds flying through the piece.

ARE YOU DRAWING THESE SKETCHES FROM MEMORY, FROM LIFE, OR FROM REFERENCE SOURCES?

Most of my sketches are from memory, and I try to do them right when I get home from a trip while the information is fresh. I visualize a lot of what we do while I am out there and create it from that. The real challenge is that 90 percent of the fishing we do is at night, so I have to feel my way through the work to put it down visually on paper. What's really fun is trying to find a rock in the middle of the night you want to fish off of that you diagramed earlier, which is fifty yards out in a rolling surf and surrounded by ten feet of water. I've spent quite a few nights bobbing around in the surf with a puzzled look on my face, thinking I know that rock I drew last season is out here somewhere.

WHERE ARE YOU WORKING ON THESE SKETCHES? DO YOU EVER TAKE YOUR SKETCHBOOK WHILE YOU'RE FISHING OR DO YOU MOSTLY SKETCH LATER AT HOME?

I always have my sketchbook in my truck when fishing. I usually put in some pretty epic trips, solo or with a group, so whenever there is downtime between bites, I'll rough in some information or make a few notes. I'll finish the sketch whenever I have the time, which may be right when I get home or the next day on the train during my commute. I do have a recurring nightmare that I lose my sketchbook on a trip, and the surfcasting world finds all of my secret fishing spots. To battle this, I change little details on my diagrams, like moving a rock slightly or adding some fake landmarks to throw off the scent. The tactics are all there, but the location is tweaked and fake names are used.

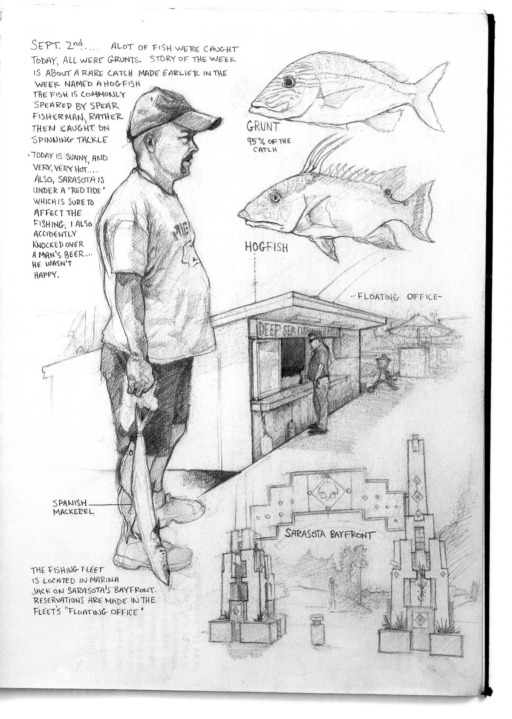

SEPT. 2nd..... ALOT OF FISH WERE CAUGHT TODAY, ALL WERE GRUNTS. STORY OF THE WEEK IS ABOUT A RARE CATCH MADE EARLIER IN THE WEEK NAMED A HOGFISH THE FISH IS COMMONLY SPEARED BY SPEAR FISHERMAN, RATHER THEN CAUGHT ON SPINNING TACKLE

- TODAY IS SUNNY, AND VERY, VERY HOT..... ALSO, SARASOTA IS UNDER A "RED TIDE" WHICH IS SURE TO AFFECT THE FISHING. I ALSO ACCIDENTLY KNOCKED OVER A MAN'S BEER.... HE WASN'T HAPPY.

GRUNT
95% OF THE CATCH

HOGFISH

- FLOATING OFFICE -

DEEP SEA FISHING

SPANISH MACKEREL

THE FISHING FLEET IS LOCATED IN MARINA JACK ON SARASOTA'S BAYFRONT. RESERVATIONS ARE MADE IN THE FLEET'S "FLOATING OFFICE"

SARASOTA BAYFRONT

HOW LONG HAVE YOU BEEN WORKING AS AN INFOGRAPHICS DESIGNER?

I've been an infographics designer for around eight years now. Ironically, I found the niche through my personal work. During college, I filled sketchbooks with informational drawings from my outdoor life. When I got my first job as a news artist, my boss and coworkers brought up the idea of doing a few infographics based on what they saw in my sketches. I fell in love with the work immediately and have been following that passion ever since.

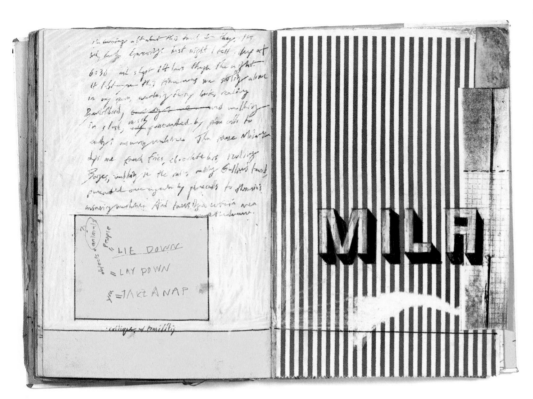

ISAAC TOBIN

Chicago, Illinois
www.isaactobin.com

Isaac Tobin is a senior designer at the University of Chicago Press. He earned a BFA in graphic design in 2002 from the Rhode Island School of Design. He worked as a book designer at Beacon Press and freelanced for a year in Buenos Aires before settling in Chicago in 2005. He is a member of the Art Directors Club Young Guns 7 and one of *Newcity* magazine's Lit 50. His work has been recognized by the AIGA, the Association of University Presses (AAUP), the Chicago Book Clinic, and *Print* magazine and has been featured in books published by Die Gestalten Verlag, Laurence King, and Penguin. In his free time, he likes to design typefaces, hang out with his wife, and cook.

YOUR SKETCHBOOK WAS THE FIRST SKETCHBOOK I EVER SHARED ON *BOOK BY ITS COVER*. IT STARTED THIS ENTIRE SERIES, WHICH EVENTUALLY BECAME THIS BOOK! I'M CURIOUS, CAN YOU REMEMBER FROM MORE THAN THREE YEARS AGO HOW IT FELT TO FIRST SHARE YOUR SKETCHBOOKS ON THE BLOG AND GET SUCH POSITIVE FEEDBACK?

It was fantastic. I made that sketchbook about eight years ago, while I was a student at RISD. In school I spent a lot of time working in my sketchbooks, and they were really well received. Everyone (myself included) seemed to prefer my sketchbooks to my finished graphic design projects. After school I started working as a book designer and decided to really dedicate myself to it. As I found a way to use book design as my chief creative outlet, I slowly stopped making sketchbooks. So when I was finally able to share them online, I was thrilled to get such a positive response.

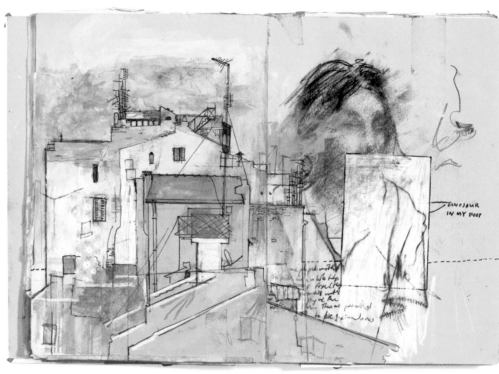

THERE ARE SO MANY LAYERS IN SOME OF THESE COMPOSITIONS. DID YOU REVISIT PAGES AND BUILD THEM UP OVER TIME, OR DID YOU WORK UNTIL THEY WERE EACH FINISHED?

A bit of both. I used to start each book by binding together a stack of all different colors and types of paper, so I wouldn't start with a blank white book but a series of textures and colors to work on top of. I'd normally start at the front of the book and move forward chronologically, focusing on two or three spreads at a time. I'd sometimes add tentative things to pages further along in the book that I'd eventually work on top of. But I'd rarely return to earlier spreads after I'd already moved on because they felt resolved and tied to the past already.

YOU MENTION ON YOUR SITE A TECHNIQUE WHERE YOU QUILT PAPER TOGETHER BY TAPING IT FROM BEHIND. WHAT WAS THE INSPIRATION FOR THIS CONCEPT?

My idea for that technique actually came from a freshman drawing teacher at RISD named Tom Mills. We made huge charcoal drawings in his class, and he didn't want our compositions to be constrained by the edge of the page. So if our drawing would grow close to an edge and we needed more room, he'd tell us to add more paper. And he'd always say "tape from behind!" so the two pages would line up smoothly. The idea stuck with me, and I realized it was a great alternative to the traditional glue-based way of building collages because it doesn't alter the texture of the paper and it makes you more aware of how every piece fits together. It's really more like inlaid wood veneers (or marquetry) than collage.

HOW DO YOU THINK WORKING IN YOUR SKETCHBOOK HELPS YOUR PROFESSIONAL CAREER AS A BOOK DESIGNER?

It was hugely important to my development as a designer, and you can see my sense of aesthetics develop from one book to the next. It was a great way to develop a sense of composition, both on one spread at a time and throughout a sequence of pages. One of my favorite things to think about while working in my sketchbooks was how each spread would lead into the next or call back to previous parts of the book. That type of thinking is vital to book interior design. I've also pulled ideas from my sketchbooks in more specific ways; I'd make my sketchbooks by binding together various colors of paper, so the front and back of a page would end up the same, often on the opposite side of a spread from a different color. I've simulated that effect in some of my book designs by printing full-bleed panels of color on both sides of a page.

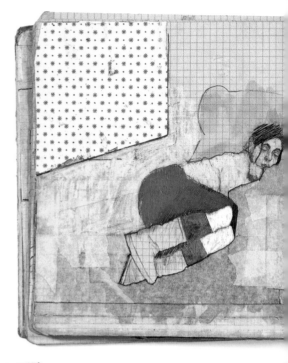

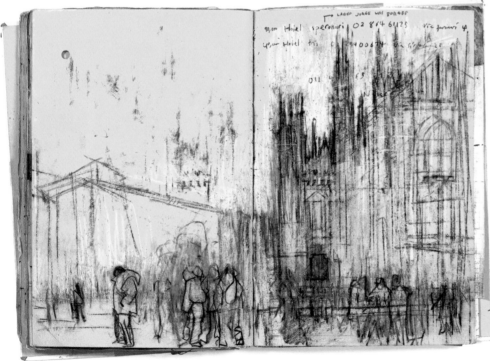

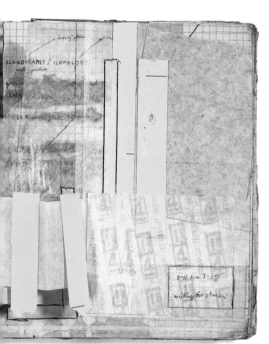

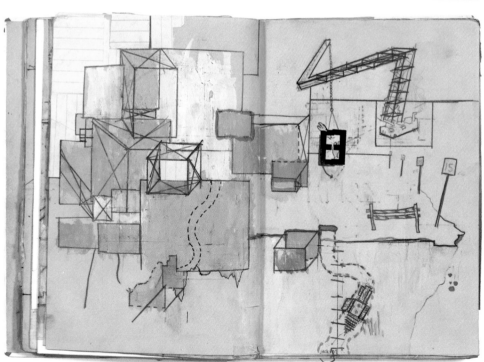

JENNY VOLVOVSKI

Chicago, Illinois
www.also-online.com

Jenny Volvovski was born in
Russia, where the winters are
long and chess is considered a
sport. These and other factors
helped her become who she
is today—a designer for ALSO,
a three-person company with
a flair for the unexpected.
Aside from working, Jenny
likes to spend time rearranging
closets and drinking fine
coffee beverages.

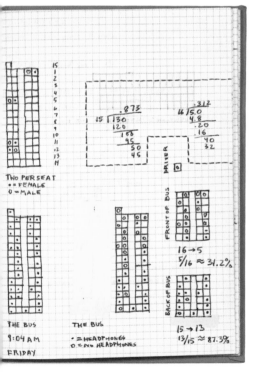

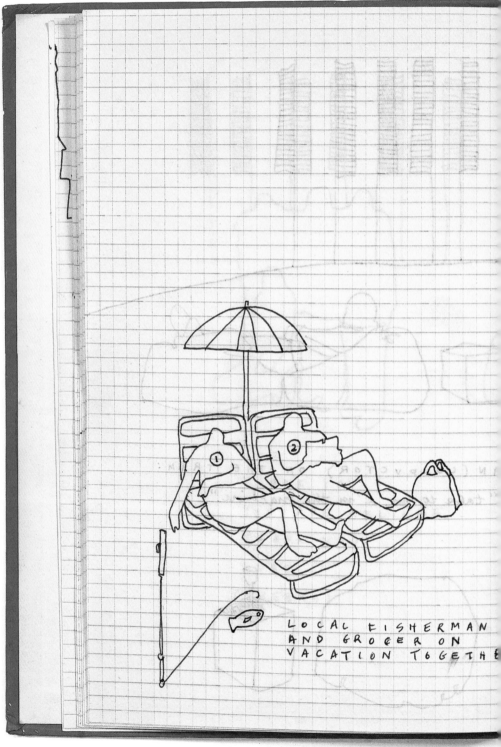

LOCAL FISHERMAN
AND GROCER ON
VACATION TOGETHE

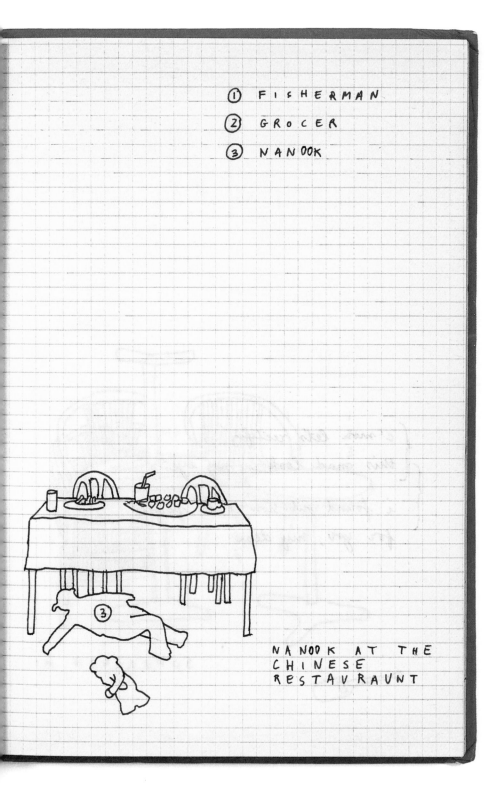

① FISHERMAN

② GROCER

③ NANOOK

NANOOK AT THE
CHINESE
RESTAVRAUNT

AS YOUR BEST FRIEND AND BUSINESS PARTNER, I KNOW YOU ARE A VERY NEAT AND ORGANIZED PERSON, ALMOST TO THE POINT OF OBSESSIVE. DID YOU EVER HAVE A SKETCHBOOK YOU WENT CRAZY IN—GOT REALLY DIRTY AND MESSY— OR HAVE THEY ALWAYS BEEN LIKE THESE?

They haven't always been quite like this, but they were definitely never messy.

CAN YOU EXPLAIN THE STORY BEHIND "NANOOK AT THE CHINESE RESTAURANT"? WHAT HAPPENED?

I was doing an internship with designer Chris Vermaas, and on my first day I went out to a Chinese restaurant with him, his wife, and their daughter, Nanook. The rest should be pretty self-explanatory.

MANY OF THESE DRAWINGS SEEM TO BE DONE WHILE TRAVELING. DO YOU FIND YOU USE A SKETCHBOOK MORE ON TRIPS AND WHY?

Yeah, most of these are travel journals. I like having a sketchbook on trips because there is so much to observe and record. I don't do much in the way of drawing and always have a really hard time coming up with content (I guess that's why I'm a graphic designer), but traveling provides me with a ton of new information that I want to remember.

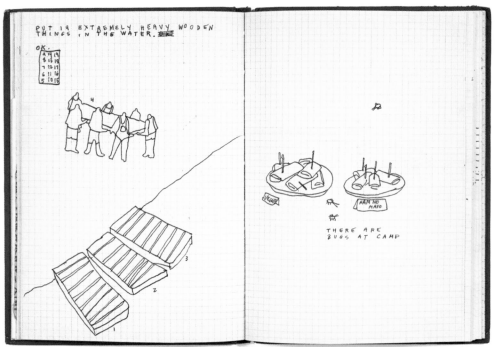

WHERE DID YOU GET THESE UNIQUE-LOOKING BOOKS?

I got most of these books while living in Rome my junior year at RISD. There was a stationery store very close to where we were staying that had an absolutely amazing selection of notebooks with misspelled covers. Some sample titles: "Adventures all through the school year and good luck for a successful future!" and of course, "Great way of climbing Think Pink was born in Yosemite National Part to relax your mind and understand nature."

DO YOU SEE A CONNECTION BETWEEN HOW YOU WORK IN YOUR SKETCHBOOK TO HOW YOU WORK ON DESIGNING WEBSITES?

I think the role of a designer is to classify and organize. I think these sketchbooks do a very similar thing, albeit in a more absurd way.

WHY SO MANY "X"S?

A while back I made a lot of drawings with my left hand. So, this was a bit of practice. The "x"s on the left page are drawn with my right hand, the ones on the right page with my left hand. The left handed "x"s have a lot to learn from their right-handed counterparts.

WHAT DID YOUR HIGH SCHOOL SKETCHBOOKS LOOK LIKE?

You don't want to know.

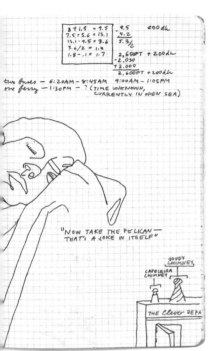

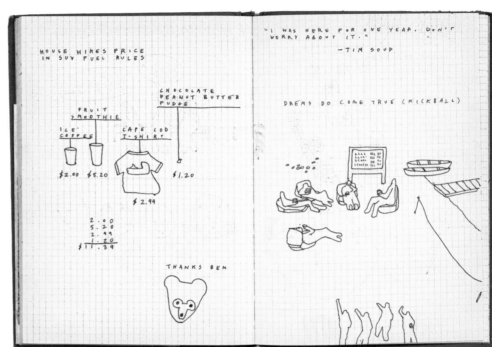

BEN K. VOSS

Brooklyn, New York
www.spacemanspocket.com

Ben Koch was born in Sinking
Spring, Pennsylvania, in 1980.
He graduated from Rhode
Island School of Design with
a BFA in painting in 2002.
He has shown work at the
Reading Public Museum,
Anderson Ranch Arts Center,
and the Aspen Art Museum.
He currently lives in Brooklyn,
New York, and is at work on
a large-scale art project called
Spaceman's Pocket.

YOU RECENTLY MOVED TO BROOKLYN, NEW YORK. HOW DID THIS RELOCATION AFFECT YOUR ARTWORK?

One big impact is that I spend a
lot of time in my sketchbook on
the subway.

HAVE YOU NOTICED RECURRING THEMES IN YOUR SKETCHBOOKS?

Well, the sketchbook featured
here is from when I was living
abroad in Rome. During this
time, I was constantly having
new experiences and wanted
to capture everything. I
wanted to be a sponge, and the
sketchbooks helped me be one.

WHAT MEDIUMS DO YOU USE IN YOUR SKETCHBOOK? HOW DO THEY DIFFER FROM YOUR REGULAR WORK?

Currently, I work with either a Sharpie ultra-fine-point pen or recently, I have been using the Sharpie pens that don't bleed. I think they just came out. It's very exciting for me. As far as my projects go, their mediums can take any form.

ARE THERE ANY CHILDHOOD MEMORIES THAT STICK OUT IN YOUR MIND THAT MAY HAVE IMPACTED YOUR ARTISTIC LIFE IN SOME WAY?

When I was very young, I had open-heart surgery, and I distinctly remember my parents coming into the hospital room with a gift for me—a giant stuffed monster.

WHAT ARE SOME PROJECTS YOU ARE CURRENTLY WORKING ON OR HOPE TO DO IN THE FUTURE?

Since 2008, I have been working on a project called *Spaceman's Project,* which is about re-imagining the universe into a new form, structure, and narrative.

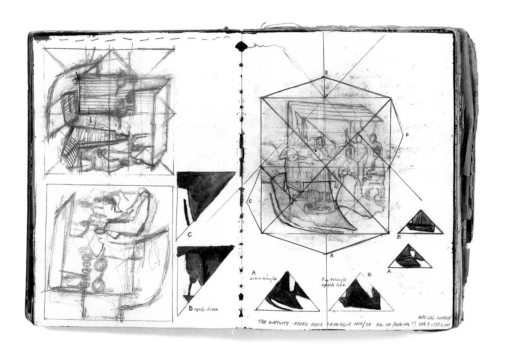

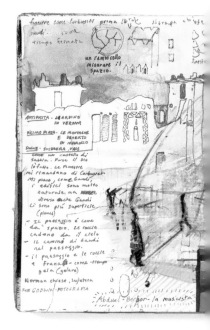

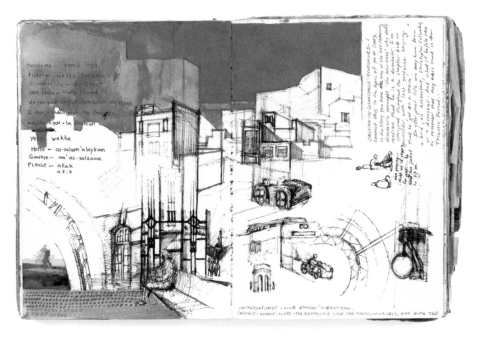

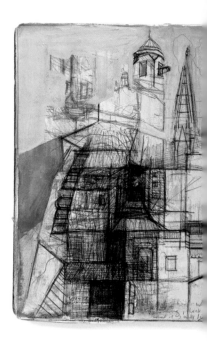

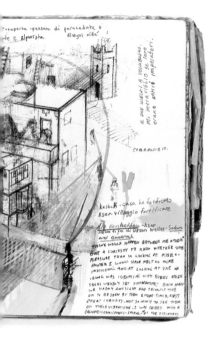

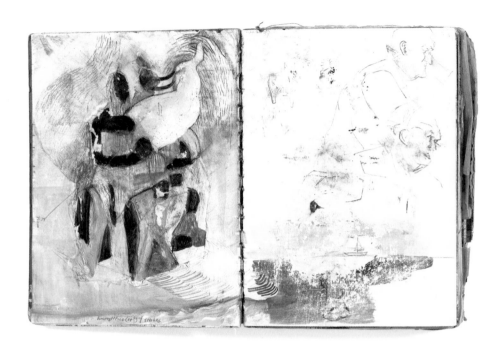

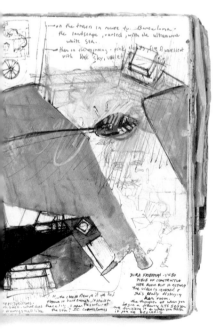

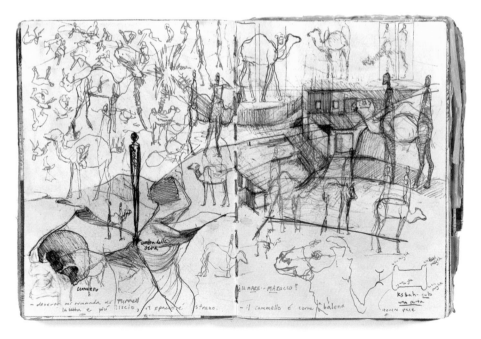

ABOUT JULIA ROTHMAN

Julia Rothman is an illustrator and pattern designer who works from her studio in Brooklyn, New York. Her drawings have appeared in the *New York Times,* the *Washington Post,* and on a line of products for Victoria's Secret. She recently created a poster design that is displayed throughout the New York City's subway system as part of the MTA Arts for Transit program. She was part of the Urban Outfitters Artist Series and designed numerous products with them for their home division. She also has a line of wallpaper, stationery, and soon, fabric. Julia is also part of a three-person design company called ALSO, which has won awards for creating animated websites for small companies. Together they authored and curated *The Exquisite Book,* where one hundred artists collaborated on a series of illustrations loosely based on the surrealist game, exquisite corpse. Julia runs a popular blog called *Book By Its Cover,* which features a different art-related book every weekday.

ABOUT VANESSA DAVIS

Vanessa Davis is a cartoonist and illustrator originally from West Palm Beach, Florida. She is the creator of *Make Me a Woman* (Drawn and Quarterly, 2010) and *Spaniel Rage* (Buenaventura Press, 2005). She's appeared in many anthologies, including *Kramers Ergot, The Exquisite Book,* and *The Best American Comics.* Vanessa's work has appeared in *Dissent, The Jewish Daily Forward,* and the *New York Times;* she is also a frequent contributor to the online magazine, *Tablet.*

THANKS

Big thanks to my very patient editor, Mary Ann Hall,
Regina Grenier, and everyone at Quarry

Jenny Volvovski and Matt Lamothe, my brilliant ALSO partners

Kipling Swehla, Lauren Nassef, Dave Zackin, Liz Zanis, Grace
Bonney, Jess Rosenkranz, Caitlin Keegan, and Matt Leines

Matty, Mom, Dad, and Jess